Oil Paintings from your Garden

A Guide for Beginners

Rachel Shirley

Guild of Master Craftsman Publications

First published 2002 by
Guild of Master Craftsman Publications Ltd,
166 High Street, Lewes,
East Sussex BN7 1XU

Reprinted 2003

Finished project photographs: Anthony Bailey
All other photographs, paintings, diagrams and illustrations supplied by the author

ISBN 1 86108 246 0

British Cataloguing in Publication Data
A catalogue record of this book is available from the British Library.

Designed by Danny McBride
Typeface: Galliard and Neuzeit Grot

Colour origination by Viscan Graphics Pte Ltd (Singapore)
Printed and bound by CT Printing Ltd (Hong Kong)

Dedication

For Harriet

About the author

Rachel Shirley has been interested in painting from a very early age and has been involved in numerous projects and art activities. Since graduating from university with an honour's degree in Fine Art, many of her paintings have formed part of private collections around the country. More recently she has had limited edition prints of her work produced by a major fine-art publisher, and won prizes in various international painting competitions – most notably, she won a trip to Alderney, one of the Channel Islands, to view the total solar eclipse of August 1999.

Rachel is still very active in various projects, including writing and illustrating children's books and holding exhibitions. She now lives with her partner, Keith Busby, and they have just started a family.

Acknowledgements

I would like to thank the following relations for the use of their gardens: Ruth and Ian Dunckley, Christine and Tim Rowley, Ros and John Busby.

I would also like to mention my nieces and nephews – Philip, Catherine, James, Samantha and Cheryl – who have been featured in some of the paintings within this book.

Finally, and most particularly, I would like to thank my parents, Sylvia and Raymond Shirley for their help and assistance, and my partner Keith, for his unerring support.

In addition, GMC Publications would like to thank Sussex Stationers, Lewes, for the kind loan of paintbrushes and Carole Haithwaite and Ian Smith for the loan of props.

Contents

Introduction

For some, taking paints and brushes beyond the realms of their own front door can be daunting. It seems that such a territory, where a mobile studio is necessary, is reserved only for those sufficiently bold and experienced to produce a work of art in public.

However, one does not have to travel far to find a wealth of material from which to paint. The haven of your own back yard is ideal for those who wish to try out oils for the first time, or to build on confidence and existing skills. There is no need to worry about packing or carrying your materials, because you are already there and all the conveniences are just a few steps away.

It is worth remembering that the light that falls on the beauty spots that attract sightseers from far and wide, comes from the same source as the light that floods your garden. Furthermore, the light in your garden is far brighter than the light that filters indoors or into the studio, even on a cloudy day. Objects are brighter, more vibrant and the contrast between colour and tone more intense.

However, should you decide to branch off into landscape painting, still life, figures, or whatever, the garden provides an excellent springboard from which to do so. Everything you need is right there, on your doorstep, waiting to be discovered and explored.

Don't worry if you think your garden has little to offer. Every garden has a unique character, no matter how ordinary it may seem at first. It doesn't matter whether it is big or small, paved or lawned, walled or open, there are hidden treasures within each and every enclosure. You just need to know where to look.

If your garden has one or more of the following, there are paintings to be derived from it: lawns, greenhouses, pots, hedges, pets, flowers, patios, trellises, sheds, children, tools, vegetables, deck chairs, furniture, swings, trees, shrubs, hanging baskets, urns, garden ornaments, bird boxes, fish ponds, skylines, conservatories – and sunlight. More can be added to this list when objects are brought into the garden.

The most ordinary, domestic gardens have been used in this book. This ensures you will find inspiration from your own garden, irrespective of its character. Each chapter deals with a different aspect of the garden, with step-by-step demonstrations.

A preliminary chapter is provided for beginners who have never encountered oils before. This preliminary chapter is divided into two parts: (1) The materials, and (2) Using oils. Those of you who are familiar with oils may still find this chapter useful. As a further guide, there is a Glossary on page 169.

The rest of this book will show how you can improve on your technique and develop your style. There is also a guide on when to use photographs and on bringing the garden indoors.

I promise that you'll wonder why you have never tried this before. There is nothing quite like sitting out on your own plot in the warm sunshine, the smell of linseed oil in the air and a dazzling scene in front of you, waiting to be captured onto canvas or board.

Everything you need to know on how to get started is covered in this book. It's easy and remarkably rewarding.

Health and safety

The same safety measures apply to oils and its associated materials as to substances commonly found in any household. All that is required is a little common sense and the observation of safety labels.

Recent developments in oils and oil-related substances mean that oils are safer now than ever before. Water-based oils, for instance, take away the necessity of solvents. Low-odour, non-flammable agents have also been developed for traditional oils.

Make the habit of storing all solvents, varnishes, oil mediums and aerosols in a cool, dark place. Never leave solvents in direct sunlight or near heat sources. Always work in a well-ventilated room and keep the lids on whenever possible. Never let oily rags build up in one rubbish pile. Soak the rags in water and dispose of them in small quantities.

When working on anything that may generate dust, for instance, sanding, always wear a respiratory mask and protective goggles.

Excessive skin contact with solvents and paints can cause skin allergies. Try to restrict the paint to the brush. Wash your hands in soap and warm water after each painting session.

Most importantly, keep all art materials away from children.

Chapter 1

If you have never used oil paints

Oil painting can seem bewildering to the beginner and the mention of oils can conjure up visions of old masters carrying out scrupulous preparations and using complex techniques. Because oils are such a versatile medium there are indeed countless techniques, but this book will demonstrate that oil painting need require neither lengthy study nor training. Times have changed and oil painting need only be as complicated as the artist wishes it to be. In fact, the cost, space required and preparation time is not so different from using water-based paints. Simplicity is the key to enjoying oils (although there are one or two more complex demonstrations within) and the following chapters will show you how.

The first chapter begins with a general description of the various materials used by oil painters and, on page 15, there is a list of the basic materials that I recommend for the complete beginner. Don't forget that there is a glossary on pages 169–70, which explains technical terms that may be unfamiliar.

The materials

Oil paints

So, what are oils? Well, if you squeeze a tube of oil paint onto a palette, a rich, buttery substance will emerge. This substance consists of finely ground pigment, which provides the colour, suspended in linseed or safflower oil.

Fig 1.1 A selection of oil paints sold in various sizes

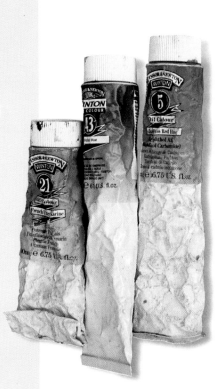

Apply it neat and you will find that oil paint can be pasted on thickly with a brush or a palette knife. This is called impasto. Water cannot be used with oil paint (with the exception of water-soluble oils, developed recently – see below) so solvents, such as turpentine or white spirit, are used to clean the brushes. Solvents, as well as other mediums, can also be used to thin the paint into washes. These are called glazes. The strong smell associated with solvents and mediums can be off-putting but, in this book, I will show you how this can be avoided with traditional oils.

Unlike other paints, oils do not dry by evaporation, but by oxidization. This means that the oil in the paint absorbs oxygen in order to harden. Depending on the thickness of the paint, a skin will begin to form after approximately three to seven days. The drying process then slows as the paint dries throughout. This can take around six to twelve months.

Oils differ from water-based paints, in that they can be reworked and manipulated at leisure. If something doesn't work, it can be scraped off and begun again. With such forgiving properties, oils are remarkably versatile. And thanks to the permanence of oils, we can still see and admire the diversity of oil techniques and styles throughout the centuries.

Traditional oils

There are two grades of traditional oils available: artist quality and student quality. Artist quality oils are designed for those demanding the highest quality pigments. These oils have a high tinting strength and are therefore more expensive. Student quality oils are designed for beginners and those on a tighter budget, and the range of colours is smaller. These oils meet almost the same exacting standards as artist quality, but expensive pigments are substituted (this is often indicated by the word 'hue' on the tube).

Tubes often carry symbols, such as 'A' or '*'. These denote permanence of colour. The more symbols present, the more permanent, or 'light-fast' the pigment is. Expense bears no relation to permanence, only to the cost of producing the paint. Occasionally, the substitute pigment used in the student quality paint has a better permanence than that of the authentic pigment. It has to be said that manufacturers constantly test and improve their pigments and most colours offer good performance.

Student and artist quality oils can be intermixed. Personally, I have found student quality oils more than satisfactory and therefore would strongly recommend them for the beginner.

Water-soluble oils

Water-soluble oils are a new product made with modified linseed or safflower oil. Winsor & Newton's Artisan and Grumbacher's Max oil paints are two of the most well-known brands. These paints behave just like traditional oil paints, but the paints can be thinned with water instead of solvents. They are ideal for people who are allergic to substances involved in using traditional oils.

Titanium White

An opaque, brilliant white. Touch-dry in five days

Lemon Yellow

A semi-transparent, acidic yellow. Touch-dry in six–seven days

Cadmium Yellow (pale)

An opaque, warm yellow. Touch-dry in six–seven days

Cadmium Red

An opaque orange-red. Touch-dry in five days

Permanent Rose

A transparent, magenta-red. Touch-dry in seven–eight days

French Ultramarine

A transparent, violet-blue. Touch-dry in two days

Pthalo Blue

A semi-transparent, greenish-blue. Touch-dry in two days

Viridian Green

A sharp, transparent green. Touch-dry in five days

Burnt Sienna

A transparent, reddish earth colour. Touch-dry in five days

Burnt Umber

An opaque, dark earth colour. Touch-dry in two days

Alkyd oils

Alkyd oils are a fast-drying paint, made from oil-modulated alkyd resin, which means that they will be touch-dry in a day. Alkyds are more transparent than traditional oils, which makes them an ideal choice for applying layers and glazes.

Feel free to try out the different types of oils, but keep the initial outlay small until you are confident with your purchase. Throughout this book, I have used student quality, traditional oils.

The pigments

It isn't necessary to have a huge number of pigments. On this page I show the pigments I regularly use on my palette and which have been used in this book. Some pigments are more transparent than others by their nature. I have given their average drying times, although different brands will vary.

As you gain more experience, you might like to try other colours. Keeping to a minimum palette, however, will give unity to your paintings.

Fig 1.2 The pigments from neat to dilute

1. Pthalo Blue
2. Viridian Green
3. Lemon Yellow
4. Cadmium Yellow (pale)
5. Cadmium Red
6. Permanent Rose
7. French Ultramarine
8. Burnt Umber
9. Titanium White
10. Burnt Sienna

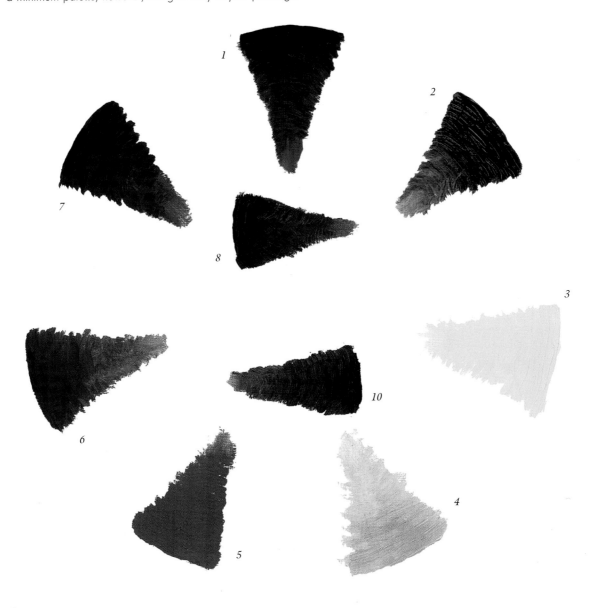

Mediums

Mediums are special agents that can be added to oil paint to manipulate its nature. I have to admit, I am inclined to use the paint neat from the tube. However, mediums can be useful for creating different effects and for experimentation and some of these will be explored within this book.

There are many different mediums available on the market, so they can be immensely confusing. To simplify matters, mediums can broadly be divided into three categories.

(1) Solvents

These are used for thinning the paint and for cleaning the brushes. Turpentine substitute and white spirit will do the job, but are harsh on the brushes and emit powerful odours. Low-odour artists' white spirit or solvents are more suitable. Sansodor and Turpenoid are two examples of thinners which are kinder to the environment, as well as the brushes.

There are ways of avoiding solvents altogether, however. One way, of course, is by using water-soluble oils. Another way is to employ several brushes simultaneously, which is what I do. Each time I mix a new colour, I use a clean brush. I often use separate brushes for dark mixes and pale mixes. Once I have finished with the brushes, I wipe the surplus paint onto a rag and then lather the brushes with soap up to the ferrule (the metal tube that connects the hair to the handle). The brushes are then rinsed in warm water and the procedure repeated until there are no traces of oil paint.

(2) Oil-based mediums

As the name suggests, these mediums contain different oils, such as linseed oil, poppy oil and stand oil. Oil mediums are specially blended with solvents in order to add transparency and flow to the paint. Oil mediums, therefore, are ideal for glazing techniques. Poppy oil is suited to pale colours, as it is non-yellowing. 'Drying' poppy oil will accelerate the drying process of the paint. Stand oil will have the effect of slowing this process down. Linseed oil already exists in the paint, and is therefore the most popular medium used for thinning and glazing.

> **Tip**
>
> Don't tip used artists' solvent down the sink. Leave it to settle in the jar for two days, then carefully transfer the clear solution into a clean jar to be re-used.

Fig 1.3 Mediums and solvents

(3) Alkyd-based mediums

These are made from a modern, synthetic resin. All alkyd mediums are fast-dryers. The most popular alkyd medium is Liquin, which is a non-glossy alternative to linseed oil. Liquin adds transparency and flow to the paint, which is ideal for glazing techniques. Impasto medium is an alkyd gel that adds body to the paint. This is ideal for impasto techniques.

Alternatives to the above agents are also available for water-soluble oils.

Fat over lean

There is a rule in applying oil paint, called 'fat over lean'. This rule dictates that if you intend to paint in layers, you must introduce more oil into your paint. This prevents cracking, as the upper layers are made more flexible. Most of the paintings in this book have been completed 'alla prima', or in one go. Working in layers, however, will be examined in more detail in Chapter 9.

Experiment with different mediums, but do not use mediums with conflicting drying rates in the same painting, as it would cause stresses in the paint and cracking might occur.

Brushes and palette knives

There are basically two types of brushes designed for oils: soft brushes and stiff brushes. Both types are sold in various shapes, the sizes of which are denoted by numbers. The higher the number, the larger the brush.

Soft brushes, such as sable and sable substitutes are springy and silky to the touch. These are good for applying detail and for smooth brushwork. Round sables are good for applying detail. Riggers are designed for applying thin lines such as branches. Fan brushes are good for washes and blending. Some sable brushes are blended with synthetic fibres, so making the brush more durable. It is worth investing in good quality soft brushes, so stick to a recognized brand.

Stiff brushes, such as hog hair are more bristly. The ends are split (called flags), so enabling the brush to hold more paint. These brushes are designed for applying larger areas of colour and for impasto. You can buy cheaper alternatives in hardware shops, but beware of very cheap brushes that moult onto your painting.

I never throw my brushes away, even when they begin to splay, as they can be used for applying glazes or for blending.

Take care of your brushes. Lather them well, up to the ferrule in soap or neat washing up liquid. Once clean, press the bristles back into shape and store pointing upwards in a jar. In the photograph on the facing page, the inner bowl shows a selection of stiff brushes; the outer bowl shows the sables. In the foreground is a palette knife, and a selection of brushes of various sizes.

Some artists use palette knives to mix their colours or to scrape the paint from the palette. These are called mixing knives. Studio palette knives are designed for applying the paint. These have a cranked handle, so that your knuckles won't catch on the painting.

Supports

The support is any surface onto which the paint is to be applied. Paper, card, wood and canvas are commonly used but traditional stretched canvas is the

Fig 1.4 A selection of brushes and palette knives

Round

Rigger

Filbert

Long flat

Short flat (or bright)

Fan

Mixing knife

Palette knife

support mostly associated with oils. Canvases can be purchased primed and stretched onto a wooden frame. Various textures exist, from fine to coarse. Some artists take pleasure in stretching and preparing their own but this can be time consuming and require special materials. I personally prefer a firm support, as opposed to one that yields. For this reason, I reserve canvases for a few specific paintings.

Fig 1.5 A selection of brushes

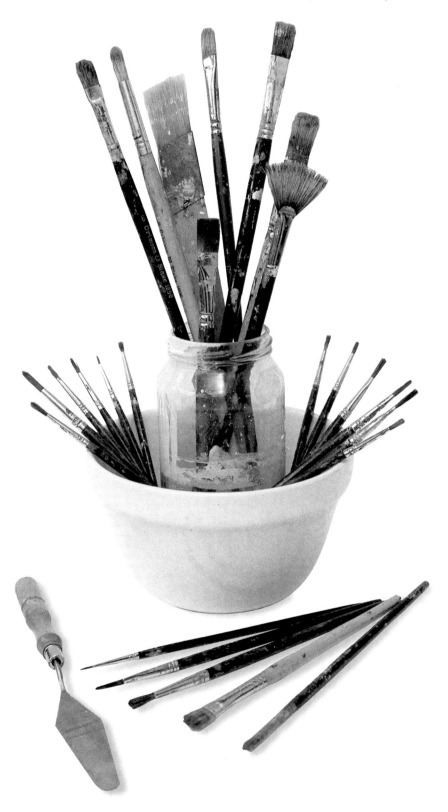

Canvas-boards are another popular support. These can be purchased from most art shops and some stationers. Canvas-boards are made with primed linen-canvas stretched and glued onto board. These require no preparation prior to painting.

Oil painting onto paper is also a recognized practice. Oil-sketching paper is available in pads and is textured in various grains of canvas. Again, these are ready prepared and can be used when necessary.

Watercolour paper is also ideal, although it will need to be properly prepared before it is suitable for oil painting. Watercolour paper is available in countless textures and grains, providing many different effects. 'HP' or hot pressed paper has a smooth surface. 'Not' or cold pressed, has a random texture. 'Rough' watercolour paper is highly textured.

Of course, the thicker the paper, the better. The thickness of watercolour paper is denoted by gsm (grams per square metre). The higher the number, the thicker the paper. The most suitable would be 300gsm or thicker.

Preparing your own supports substantially cuts the cost and adds flexibility to your demands. The support I would recommend for this purpose is medium density fibreboard (MDF). MDF can be purchased from hardware shops in large sheets. It has a smooth surface, and is easier to cut than hardboard. It is also inexpensive. Unless indicated, the paintings in this book have been completed on hardboard or MDF.

Grounds

When preparing your own support, the surface must be properly sealed to make it suitable for oil painting. If oil paint is applied onto an unprepared support, the oils in the paint will be absorbed into the surface, so retarding the oil's ability to flow. The pigments would dull and may even flake off.

Types of supports
(a) Primed MDF
(b) Canvas-board
(c) Primed watercolour paper
(d) Oil-sketching paper
(e) Stretched canvas (fine grain)
(f) Stretched canvas (medium grain)
(g) Stretched canvas (coarse grain)

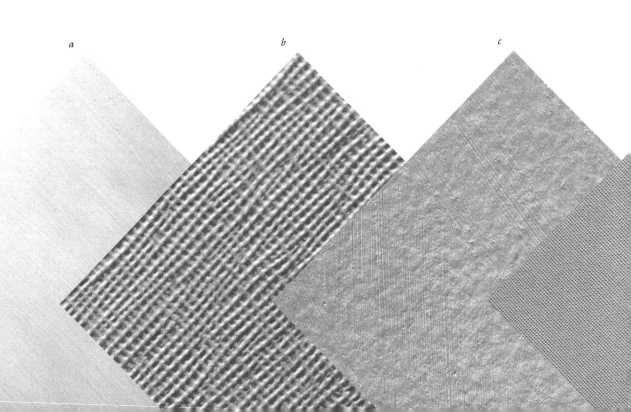

a *b* *c*

A good ground will seal the porous nature of the support, so that the oil paint can sit on top. More importantly, it will protect the support from the rotting effects of the linseed oil. Grounds, therefore, describe any substance that is applied onto the support for the oil paint.

All sorts of grounds are available on the market, such as emulsions, oil-based primers, glue size and gessoes.

In case you wish to experiment with different grounds, I will describe briefly the main ones.

Gesso is the oldest type. Gesso is chalk or whiting suspended in a glue binding agent, which is bought from art shops in powder form. A warm coat of glue is often required on the support first. This is called sizing. The gesso mixture is then applied on top.

Oil-based primers provide a more glossy finish. Again, a coat of size is required before the oil-based primer can be applied. This primer takes a day to dry and brushes must be cleaned in solvents afterwards.

Acrylic polymer primer is the easiest to use and the one I would recommend. This is a brilliant white, fast-drying, water-based paint. Two coats in a ventilated room at an hour's interval is all that is needed; a further coat may be necessary if the support is particularly absorbent. The primer dries water-resistant, so brushes need cleaning in warm, soapy water immediately afterwards.

Acrylic primer is sometimes sold as 'acrylic gesso primer'. However, unlike the aforementioned gesso, no glue or sizing is involved. Look out for the word 'acrylic' on the tin. Read the manufacturer's instructions if you are still unsure.

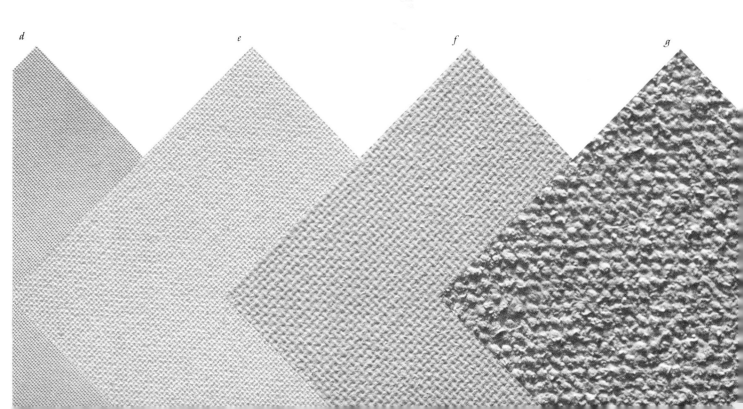

d *e* *f* *g*

The easel

When painting outdoors, I fasten my painting onto a board, and rest it on my lap or against the edge of a table. If the painting is large, an easel will be used. I use a lightweight metal sketching easel.

There are all sorts of easels available, to satisfy any demand. Box easels are designed for those who prefer to sit. These can be rested on the lap or any stable surface, such as a table. The lid opens up into an easel and the box itself provides storage for the art materials.

Beechwood lightweight sketching easels are an alternative if you prefer to stand, although some can be tricky to set up and unstable in the wind. Metal easels are an alternative, and some are manufactured with a seat for convenience. When purchasing an easel, ensure it can be folded compactly.

Studio easels are designed to be a permanent fixture. These are bulky and costly and therefore unsuitable for painting in the garden.

Other materials

Acrylic paints are not essential, but I find them useful for applying underwashes to an oil painting. The underwash is usually done with diluted oil paint, which can take up to two days to dry. Acrylics are more convenient in that they dry in an hour or so. It must be noted, however, that acrylics should never be applied over a surface prepared with an oil-based primer.

Rags are invaluable. I use them to wipe the surplus paint from my brush and my hands. Save old T-shirts and linen (but don't use fibrous material such as wool). Cut them into approx. 30cm (1ft) squares and store along with the rest of your art materials. Of course, no art kit would be complete without a pencil sharpener, eraser and a soft pencil (I use a 2B).

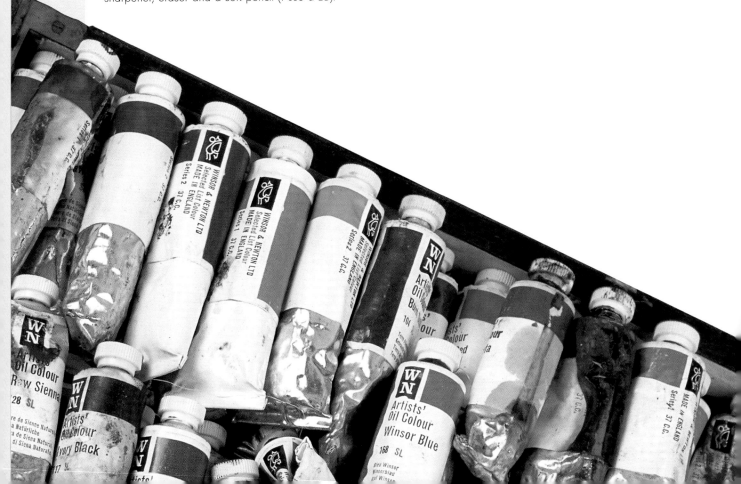

Recommended art materials for the beginner

Pigments

Student quality traditional oils (such as the Daler-Rowney's Georgian range, or Winsor & Newton's Winton range) or water-soluble oils if you prefer not to use traditional oils.

115 or 120ml (3.90 or 4 U.S. fl.oz) tube of titanium white. 37 or 38ml (1.25 U.S. fl.oz) tubes of the colours listed on page 5.

Solvents

Washing up liquid and/or a bar of soap. 250ml (8.4 U.S. fl.oz) bottle of low-odour artists' solvent, such as Sansodor.

Mediums

All are optional. 75ml (2.5 U.S. fl.oz) jar of linseed oil is the most useful.

Brushes

Purchase the short-handled variety. They are cheaper and easier to store.

Sable or equivalent. Nos. 00, 1, 3 and 6 round variety.
Hog or other bristle. Nos. 4, 6 and 8 flat or filbert variety.
Buy three or more of each brush if you can.
Optional: a fan brush.
Optional: a medium palette knife.

Supports

It is up to you to decide whether to purchase ready-prepared supports or to prepare your own.

Ready prepared supports

Canvas-boards and/or ready-stretched and primed canvases, available in various grains.

A pad of oil-sketching paper. These are usually available in 12-sheet pads.

Making your own support

If you decide to prepare your own supports, I would recommend 2mm (⅛in) thick MDF. Use 3mm (⅛in) for paintings larger than 30.5 x 40.5cm (12 x 16in), or alternatively, hardboard. MDF is usually available in 61 x 122cm (2 x 4ft) sheets.

You will also need a tin of acrylic primer 500ml (16.8 U.S. fl.oz) approx. from a recommended brand, a 5cm (2in) wide paintbrush and fine glasspaper.

Optional: A pad of 300gsm (or heavier) watercolour paper. 'Rough' or 'Not' surface.

Supports are usually sold in imperial. The sizes I would recommend are: 8 x 10in (203 x 254mm), 10 x 12in (254 x 305mm), 12 x 16in (305 x 406mm), 14 x 18in (355 x 457mm), 16 x 20in (406 x 508mm) and 20 x 24in (508 x 610mm). 19¾ x 27½in (500 x 700mm) is the largest used for the demonstrations in this book. All these sizes are compatible with ready-made frames widely available.

Palette

Primed board or any rigid white/neutral surface, 18 x 28cm (7 x 11in) approx.

Sheets of clear A4 plastic

Pack of bulldog clips

Other materials

Optional: 60ml (2 U.S. fl.oz) tubes of acrylics in the following colours: pthalo blue, permanent rose, cadmium yellow and burnt sienna.

A 2B pencil, rubber, pencil sharpener, plenty of rags and two clean jars.

A viewfinder may also come in handy. More about this in the following chapter (see page 26).

Using oils

Your first brush marks

Numerous techniques can be employed when using oils. This prospect may excite some and daunt others but the best way to learn is simple – just have a try. This may seem like jumping in at the deep end but, I promise, you will surprise yourself. Oils are a fun and indulgent medium. They are also robust. If you don't like the colour you have applied, you can work over it, into it, or simply wipe it off.

Practise your first brush marks on a piece of primed card or cheap oil-painting paper. Ensure you have a sufficient amount to give yourself free rein. Place 12mm (½in) of low-odour artists' solvent into a clean jar. Next, squeeze out a cherry-sized dollop of each colour onto your palette, with twice as much white. Leave plenty of room between each colour. It is a good idea to arrange the colours from warm to cool around the white. If you place the colours in the same order each time, you will soon mix the colour you want without having to look at your palette.

Tip

Don't force stubborn paint tube lids. Run the lid under a hot tap. The paint will soften and the lid should ease off.

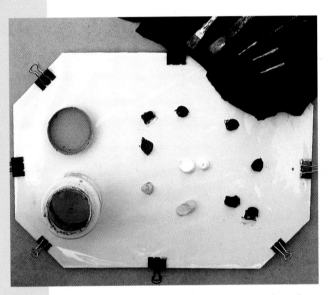

Fig 1.10 Arrange the colours on your palette from warm to cool around the white. If you place them in the same order each time, you will soon mix the colours you want as second-nature.

Fig 1.11 You will save paint if you place a plastic tub over the palette when you have finished for the day. Keep in a cool place. The paints will still be usable the next day.

Ensure you have plenty of time to experiment. If you don't know where to begin, try out each colour from neat through to dilute. This can be done by introducing a little of the solvent into the pigment each time. Wash your brush and dry thoroughly on a rag between each application.

Now try the different brushes. Notice how the paint behaves with each brush. Smudge the paint. Use rags or a palette knife.

Now try mixing two colours together. Leave streaks of pure colour within your mixes. Try blending them. Experiment in as many ways as you can.

Don't throw away your doodle-board when you have finished. Allow the colours to dry, and then have a go at painting over some of the colours another day. Discover for yourself how transparent some colours are. If you dilute the pigment enough, you can see the colour beneath; notice how this resultant colour differs from when the two are simply mixed together. If you dry your brush and load it with paint, the application will have a creamy quality. Allow your brush to form peaks and troughs on the board. Don't be tempted to smooth out the paint or to reproduce the same brush mark.

You have just learned the two basic techniques of using oils: glazing and impasto.

Fig 1.12 Doodle-board

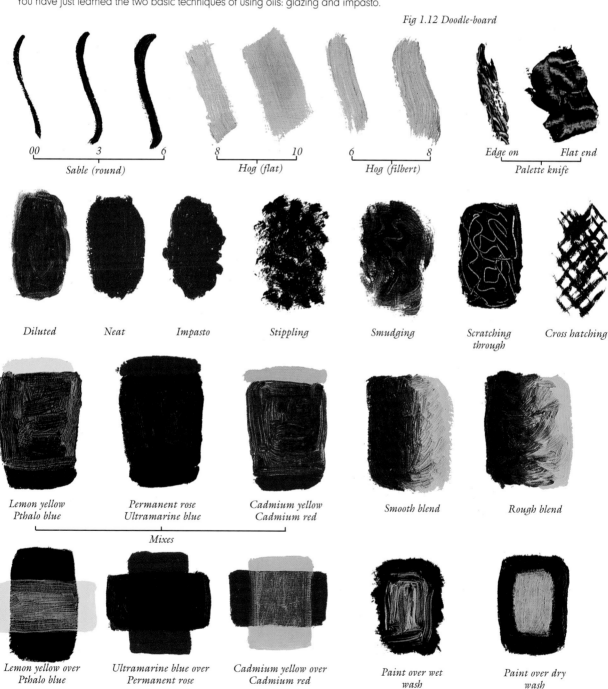

00	3	6	8	10	6	8	Edge on	Flat end
Sable (round)			Hog (flat)		Hog (filbert)		Palette knife	

| Diluted | Neat | Impasto | Stippling | Smudging | Scratching through | Cross hatching |

*Lemon yellow
Pthalo blue* · *Permanent rose
Ultramarine blue* · *Cadmium yellow
Cadmium red* · *Smooth blend* · *Rough blend*

Mixes

*Lemon yellow over
Pthalo blue* · *Ultramarine blue over
Permanent rose* · *Cadmium yellow over
Cadmium red* · *Paint over wet
wash* · *Paint over dry
wash*

Glazes

Mixing colours

Understanding how oil paints behave when colours are mixed is essential and problems can arise if the traditional colour wheel is used as a guide.

The colour wheel is a chart showing the spectrum. In theory, all colours are made from the three primary colours, red, yellow and blue. Mix any two and this will result in a secondary, green, orange and violet. Mix a primary with a secondary, and a tertiary will result: red-orange, orange-yellow, yellow-green ... and so on.

However, in practice, this does not work. If you mix ultramarine blue and cadmium yellow, a vibrant green will not result, but a rather muddy colour. Mix cadmium red with pthalo blue, and the resultant colour is almost black rather than violet. Try lightening it up with white and it will turn out grey. This is because the true primary colours are magenta, yellow, and cyan, not just any red, yellow and blue, as is traditionally thought. However, no pigment found is as pure as the colours of scattered light, so the best that can be achieved is a close approximation.

Cadmium yellow (pale), permanent rose and pthalo blue are quite close to the mark. The traditional pillar-box red is not really a primary colour at all, but can be made from a mixture of permanent rose and cadmium yellow. Small wonder then, that if red contains yellow, it makes for a muddy purple.

The colour wheel I have devised in Fig 1.13 shows a close approximation of the primary colours and how they mix. Using the pigments recommended, cleaner mixes will result but experiment with mixing the other pigments, too. Apply them onto your board and see what happens. The doodle-board on the previous page will help get you started. Getting to know your colours means getting to know how they mix.

Tones

Without the distraction of colours, we can see their tonal values. One of the interesting things to note, is that blue, which is often thought to be a dark colour, can very often be lighter in tone than orange. Likewise, red is often darker than green. Totally different colours can have identical tonal values.

On your doodle-board, experiment with tones. Begin with a mid-toned colour and then lighten it up, by introducing a little white each time. Now try darkening it. This can be done by introducing the colour's complementary colour.

Take a look at the colour wheel. The complementary colour can be located on the opposite arc to your chosen colour. For example, the complementary colour of green is magenta (or primary red). These two colours are therefore opposites. If you introduce a little of this red into your green, the green will try to cancel out the red. In doing so, the green will darken. Add more of this complementary colour, and the original colour will become neutral. Darkening colours in this way will take the mud from your mixes.

Fig 1.13 The colour wheel

*Violet
(secondary)*

*Magenta
(primary)*

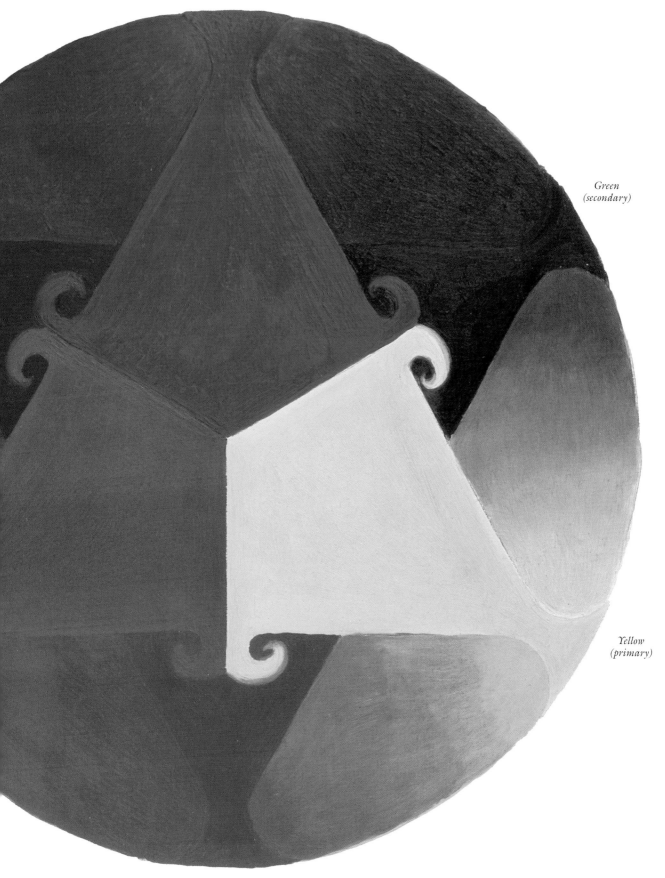

Cyan
(primary)

Green
(secondary)

Yellow
(primary)

Red
(secondary)

If all this seems a little too much to take in, don't worry. As you work through this book, the science of colours and colour-mixing will become second nature. Eventually, you will feel sufficiently confident to move onto the next step: painting from life.

Fig 1.14 The tones

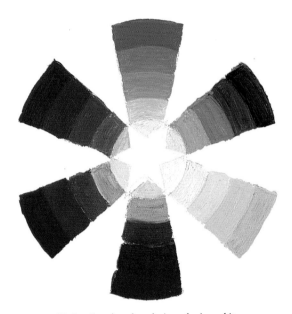

Lightening the colour by introducing white

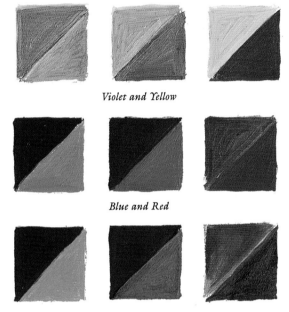

Violet and Yellow

Blue and Red

Magenta and Green

Any colour can be paler or darker than its neighbour

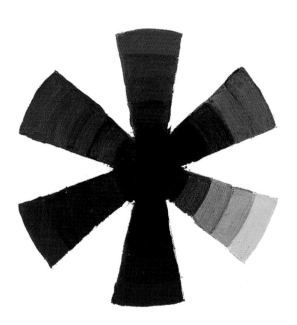

Darkening the colour by introducing its complementary

Cadmium red + Pthalo blue *Viridian green + Permanent rose* *Burnt umber + Ultramarine blue*

Different blacks

Yellow pale *Cream pale* *Blue pale*

Different pales

Chapter 2

Making a start

I firmly believe that oils are the ideal medium for portraying the many aspects and moods of the garden: rose heads and hanging baskets lit up against a luscious backdrop; patio furniture casting long shadows on a summer's evening; children frolicking in jazzy costumes around the pool; a cat snoozing on a wall; crazy paving mirroring the sky after a downpour; hefty showers bearing down on a skyline of blossoming trees; families enjoying siestas on deck chairs; evergreens cradling thick, crimson snow; birds bathing in bird tables on a dewy morning...

All of this can be achieved with oils: the density of oils applied neat; the delicacy of thin washes; using rags, newspaper and palette knives as well as brushes; scratching the paint; smoothing the paint and pasting it on thickly; smudging, stippling and scrubbing. There is a technique to suit every occasion.

This chapter aims to help you see your garden in a new way. You will then be ready to start exploring such techniques in oils.

Seeing your garden with a new eye

Take a long look at your garden. Don't look for anything in particular, just let your attention drift and allow your feet to roam. Take a notebook with you. Make little sketches and take photos if you wish, although photos are never a substitute for

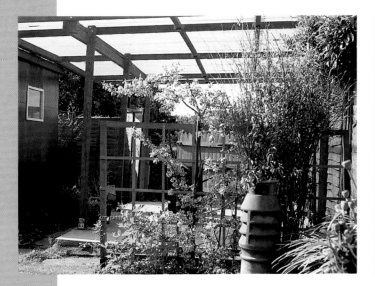
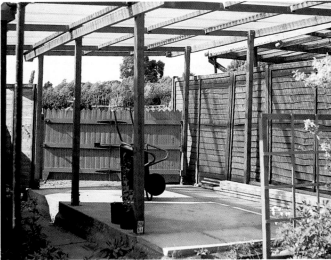

Figs 2.1 (a–d): These four pictures were taken just a few feet apart, crouching and standing. Notice how a small shift in viewpoint can radically alter the composition.

the naked eye. Record anything that interests you – no matter how small or insignificant it may seem. Lose yourself. Imagine that you have never been here before. The pointers listed below may help.

The viewpoint

No matter how familiar the garden may seem, it harbours secrets. Every garden has well-trodden areas, like paths and lawns. But the same garden can look very different from an unfamiliar angle. A few feet to the left or right can change things radically, as can kneeling to get a different viewpoint. Take a walk towards an area you have seldom visited. Look around and take in the scenery from the new angle. You cannot predict how the viewpoint will affect what you see.

The light

Make a note of where the sun falls in relation to the garden. Is there a particular part of the garden which is shady, or where a pool of sunlight persists? Make a note of any feature in the garden that looks interesting during a certain time of the day. Revisit the various viewpoints at different times. I promise, they will look different again. How sunlight affects the composition will be explored in more detail in Chapter 6.

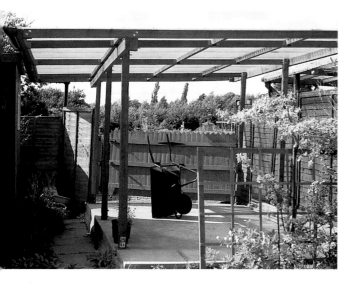

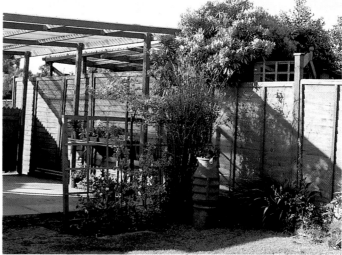

Backgrounds

Background is important to a good painting. It doesn't have to be colourful or eye-catching. In fact, simple or subdued is often ideal. A sun-dappled lawn, a wooden fence, dense foliage, climbing ivy or a brick wall, all make interesting backgrounds.

Figs 2.2: (a) A brick wall (b) Foliage (c) Pebble dash (d) Crazy paving

a

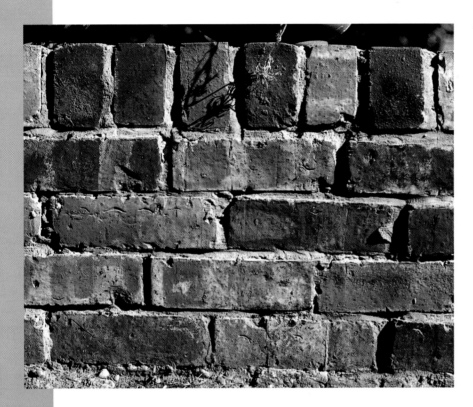

b

A feature

Single out an object that interests you, such as a fuchsia head, a window box, a bird table, a water feature. The most mundane and ordinary objects can take on special significance when viewed from a certain angle or under certain lighting conditions. Never dismiss an object as being too mundane.

The seasons

Don't worry if you can't find anything that inspires you at first. The garden is constantly changing and growing: the colours of autumn and spring adorn the garden in totally different ways; summer intensifies the light and deepens the shadows; winter opens up the sky and makes the garden appear more roomy. Take the view that your search for inspiration is ongoing. Something may strike you at any time - whether you are digging the garden or lounging on a deck chair. Examples of how the seasons affect the garden can be seen throughout the book.

Exert artistic licence

Flower pots, gardening tools, deck chairs and vegetables can all be moved around. Crockery, toys, ornaments, clocks and even goldfish bowls, children and pets can be moved into the garden from the house. Anything can be moved into or around the garden in order to add interest.

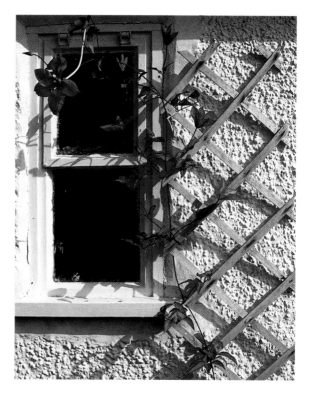

d

The viewfinder

You might find yourself overwhelmed after your exploration of the garden, and unsure of where to begin. If so, a viewfinder may help. Using a viewfinder will enable you to see things more clearly by filtering information.

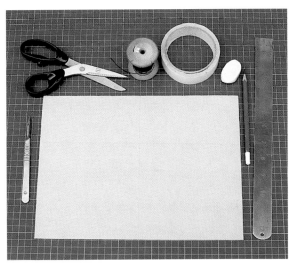

1. Making a viewfinder couldn't be simpler. All you need are a sheet of card at least 28 × 20cm (11 × 8in), thread, double-sided sticky tape, a ruler, a pencil and a penknife.

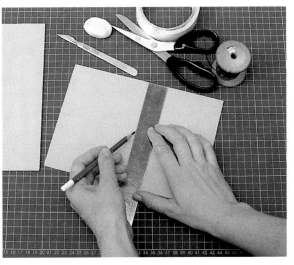

2. Cut the card in half. Ensure both halves measure approximately 14 × 20cm (5½ × 8in). Draw a cross in the centre of each piece of card.

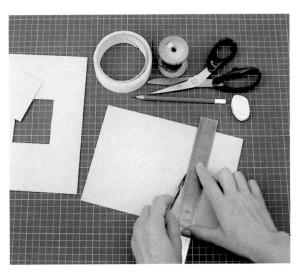

3. Cut a hole measuring 6 × 7.5cm (2½ × 3in) in the centre of each card.

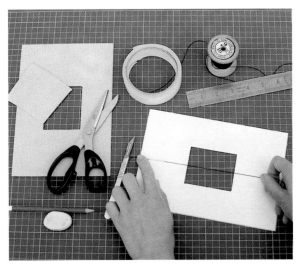

4. Place double-sided sticky tape onto each halfway line, then position a piece of thread 24cm (9½in) long over each line and press onto the tape. To ensure the thread is taut and stays in place, overlay it with more tape.

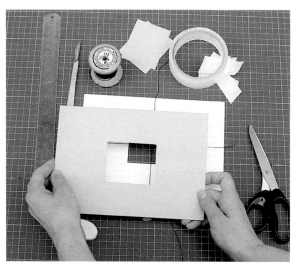

5. Put random pieces of tape around the window and place the
other card over the top. Trim the string.

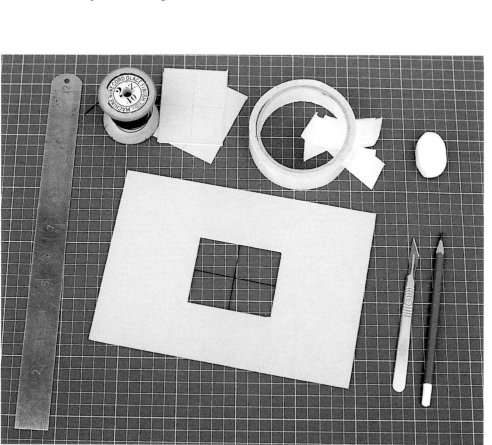

6. The viewfinder,
ready for use.

The proportions of the window and the thread will help in ways that will be made clear in the following chapter. For now, practise using the viewfinder. Close one eye and look through the window. If you hold the viewfinder at arm's length, the window cuts out the surrounding area and focuses more on an object. If you hold the window closer to your eye, the view becomes wider, revealing more of the surroundings.

You can also hold the viewfinder in portrait or landscape mode, depending how you wish to compose your picture.

Fig a: A fixed view of an object can be further manipulated by its format. This shows a narrow view of the apples in landscape format.

Fig b: This is a wider view of the apples. More of the background is revealed and the apples are emphasized less.

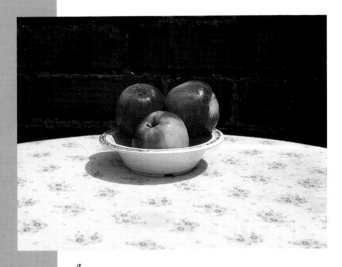

a

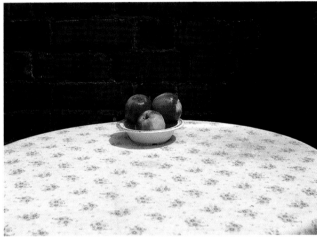

b

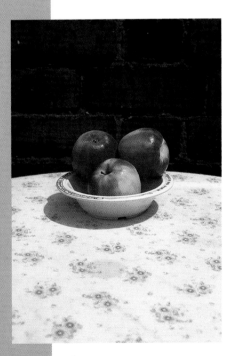

c

d

Fig c: As opposed to (a) and (b), which are in landscape format, this view of the apples is in portrait format. The top and bottom of the picture are emphasized.

Fig d: This view of the apples is wider. Like (b), the apples are emphasized less.

Revisit the places of interest in your garden and take a look through the viewfinder again. Your original ideas may seem different this time around.

Painting in comfort

Only you can decide how best to set yourself up during painting, but comfort is paramount. A stiff neck or an aching back can easily be forgotten whilst you are busy trying to capture the light.

Plenty of elbow room is important for painting, so a deck chair or sun couch would be ideal. If you decide to place your paints on the ground, lower the seat so that they are within easy reach. Adjust the seat to ensure you are sitting comfortably when painting.

A low stool is more mobile and can be placed in more confined places in the garden. Ensure it is stable and that, when you are seated, your thighs are parallel to the floor. A tripod stool is good for painting purposes. These are more comfortable than they look and can be purchased cheaply in camping and fishing shops. Of course, you can always make use of anything available in the garden, such as a low wall or a rockery - or even the ground - but be sure to cushion yourself against any hard surface.

Personally, I prefer an informal setting, with minimal clutter. Just me, a stool and my paints - unless I'm working big, in which case, I'll use an easel. If you do decide to use an easel, consider the advice on easels given in the previous chapter.

Sometimes, I like to stand and paint but usually, I'll sit, resting my painting on my lap, or against the edge of a table. From time to time, I'll hold my painting up to see how it compares with the setting.

> ### Tip
>
> Set out your art materials on top of an old sheet. They can then be gathered up quickly if the weather changes. If there is a breeze, the sheet and palette can be weighed down with stones from the garden.

Beware of hot spots in the garden, and also of bright sunlight bouncing off the painting surface. If possible, sit in the shade or under a parasol. Wear a hat and sunblock. A cool drink always comes in handy. There is nothing wrong with wearing sunglasses, for they cut out the glare and make the sky stand out. But take them off from time to time when recording colours.

Lastly, don't wear your best clothes whilst painting. Although oils can be clean if handled with care, I have, unintentionally, dropped my brush and flicked paint onto my clothes.

A painting in four stages

I like to think that there are four main stages to completing a painting in the garden. The actual painting is the final, and sometimes, the most straightforward stage.

Firstly, finding a composition. This can involve some thought. Much viewing, pacing around, swapping and changing of objects is sometimes necessary.

Secondly, the drawing. I often do this on a dull day. This takes away the urgency of getting down to painting if the light is good. The best of the light will be saved for when you are ready. Make a note of where the drawing took place in relation to the subject matter for when the right time comes. A good composition and drawing will form a sound base for a successful painting.

Thirdly, decide on the underwash of your painting. The underwash is the colour that will be applied (if any) onto the painting surface. More on this later.

Fourthly, the painting. If I plan to paint the next day, then I will prepare my palette and materials in readiness. Think about the time factor before you begin painting, too. This may seem obvious, but I have been caught out on occasion. Consider where and when the shadows are likely to creep at certain times of the day. Set yourself up accordingly. It would be pointless to begin a sunlit painting in late afternoon if the sun sets behind your house.

Get to know your preparation time. Allow yourself more time than you think you need. This ensures that the optimum light is used during the painting.

The underwash of your painting

There is nothing wrong with painting straight onto a white surface, but I find that a thin wash of underpaint adds depth and vibrancy to the finished painting. Such a wash is called an *imprimatura*. The *imprimatura* provides a useful key from which the tones of the painting can be set. On a white, primed surface, for example, a pale colour will appear dark, thus creating a misleading impression of its tone. Examine Fig 2.6 on the facing page. The neutral underwash reveals the true paleness of the green.

Oil paint diluted with artists' solvent is the usual practice for an *imprimatura*. This takes around two days to dry. An underwash of diluted acrylics, however, is my preferred method. It dries quickly and there is no need for solvents.

Painting straight onto a wet wash is called 'wet-into-wet'. This adds a more liquid and flowing quality to the painting and is difficult to control. Always use an oil wash if you intend to practise wet-into-wet. (N.B. This technique will be examined in more detail in Chapter 10.)

A diluted earth colour such as burnt sienna or burnt umber is often used for an *imprimatura*. However, one can experiment with different coloured washes. Applying an acrylic underwash couldn't be easier. Figs 2.7 (a–e), pages 32–3, show the application of a transparent wash. Figs 2.8 (a–c), p. 34, show the application of a dark wash. Figs 2.9 (a–d), pages 35–6, show the application of an opaque wash.

Fig 2.6 The green looks dark against a white background. However, a neutral underwash reveals the true paleness of the green.

Applying a transparent wash

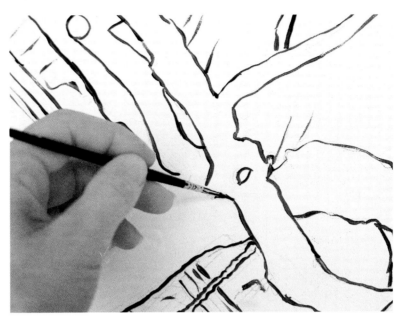

Fig 2.7 (a) A transparent wash is the type most widely used. Firstly, ensure the drawing will be seen beneath the wash. You can do this with a dark pencil or thinned acrylic. Avoid using a pen, as this can bleed through the layers of paint. In this case, I mixed pthalo blue and permanent rose in a small receptacle. It doesn't matter what colour you use, so long as the colour is dark. I added two to three drops of water to make it flow.

Fig 2.7 (b) With a 00 sable brush, I applied the acrylic paint over the pencil lines. Remember to clean the brush as soon as you are finished, as acrylic dries water-resistant.

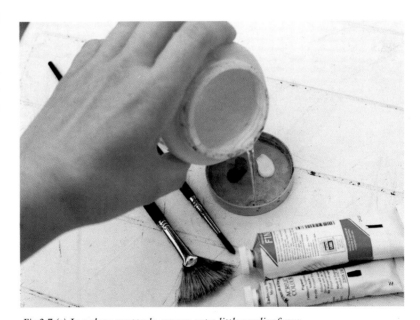

Fig 2.7 (c) In a clean receptacle, squeeze out a little acrylic of your chosen colour. I used cadmium yellow and permanent rose. Add sufficient water so that, once mixed, the colour will be transparent. Ensure there will also be enough of the mixture to cover the board.

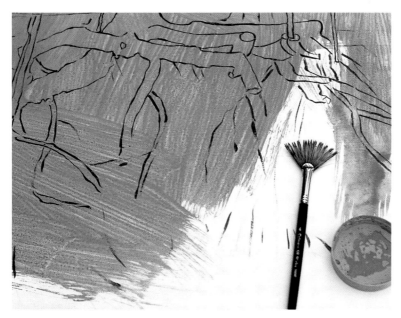

Fig 2.7 (d) Once the drawing is dry, apply the wash with a soft, wide brush. The drawing will show through the wash.

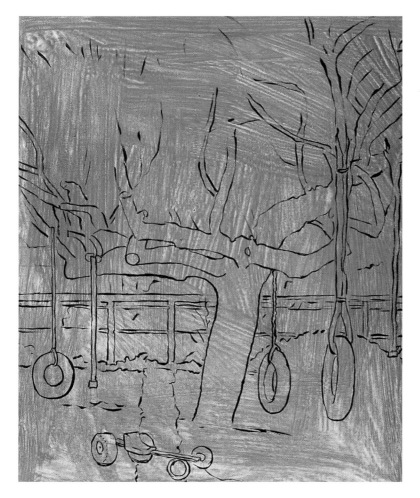

Fig 2.7 (e) Once the wash is dry, the surface is ready for oil painting.

Applying a dark wash

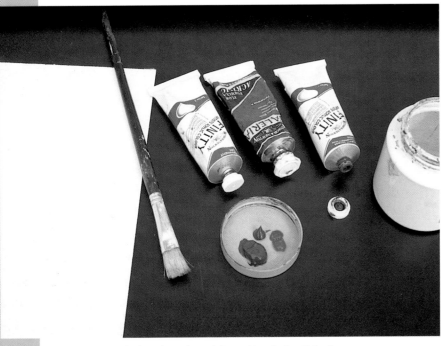

Fig 2.8 (a) A dark wash can be used for working dark to light. In this example, I used a mixture of burnt sienna, pthalo blue and permanent rose. I mixed these colours with a few drops of water in a small container.

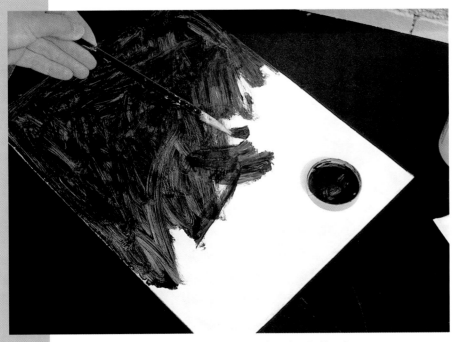

Fig 2.8 (b) With a wide brush, I sloshed on the paint. I allowed any streaks of colour to remain on the board.

Fig 2.8 (c) Once the paint is dry, a pale chalk or pastel pencil can be used for the drawing stage prior to painting.

Applying an opaque wash

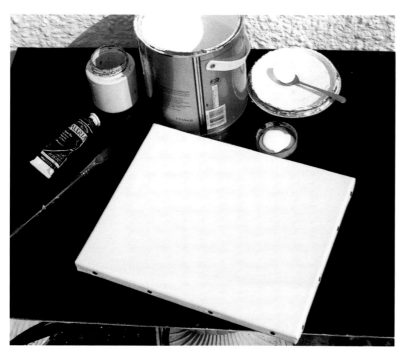

Fig 2.9 (a) An opaque wash can be used by mixing your chosen acrylic colour with acrylic primer. Take three to four large spoonfuls of acrylic primer and place them in a separate container.

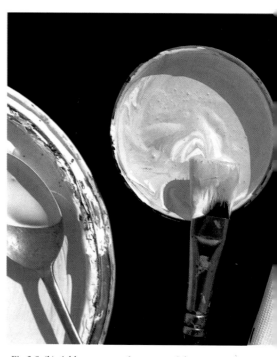

Fig 2.9 (b) Add a quarter of a teaspoonful of your chosen colour. In this example, I used pthalo blue. Mix well. If the tint is too pale, you can always add a little more colour.

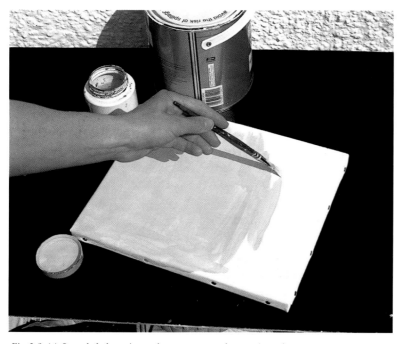

Fig 2.9 (c) I needed the paint to be runny enough to go into the weave of the canvas, so I added a little water. It is up to you to decide on its consistency. Apply the paint with a wide brush.

Fig 2.9 (d) Once the paint is dry, it is ready for your sketch prior to painting.

There are demonstrations, showing how these paintings were completed, in the following chapters.

The colours that can be used for an underwash are limitless. I usually have a small selection of boards, ready-tinted in various washes to suit the subject of the painting and the mood I wish to convey.

How to use the *imprimatura* to manipulate the mood of your painting is examined in more detail in Chapter 4.

Chapter 3

Simple is effective

YfYou will probably have prepared your art materials as outlined in Chapter 1. You may also have collated notes, sketches, photographs and ideas as likely sources for inspiration. Hopefully, you will have considered your seating arrangement for when the time is right. You may even be eager to begin painting. Or you may be thinking – what now? This chapter contains a simple exercise to help build your confidence and get you started.

Objects in the garden are more interesting

The simplest everyday objects come to life in good, natural light and, when carefully arranged in the garden, they exude a beauty not normally observed indoors.

I have selected three such objects, all contrasting in shape, colour and tone and I suggest you do the same. Firstly, select a pot. Preferably, one that is free of detail. Try to find an empty one, or at least one containing a small plant. Secondly, a rounded fruit or vegetable – an onion, a lemon, a pepper or an apple will do. Thirdly, a small garden fork. If you haven't got one of these objects, substitute it with one that interests you.

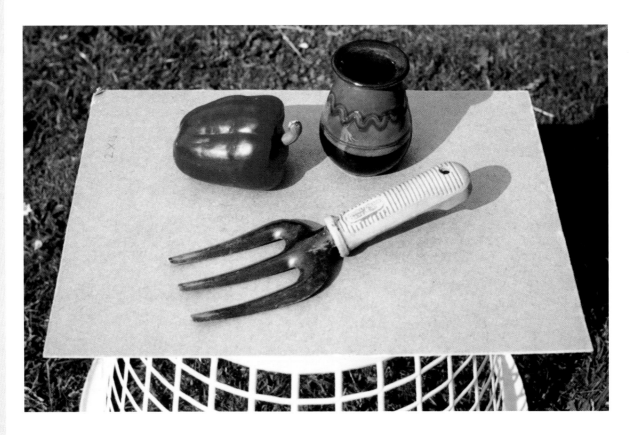

Arrange these objects on a piece of board or MDF and place the arrangement onto a patio table or stool, or any other stable surface within the garden. Sit back and take a look.

Firstly, cut out the clutter. Hold up the viewfinder and edit the background as shown in Fig 3.1 (b). Cut the clutter further by half closing your eyes. This will break down the scene into its basic components, as shown in Fig 3.1 (c).

Fig 3.1 (a) Examine the composition.

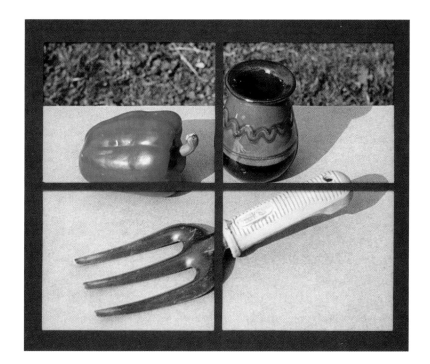

Fig 3.1 (b) Edit the background by using the viewfinder.

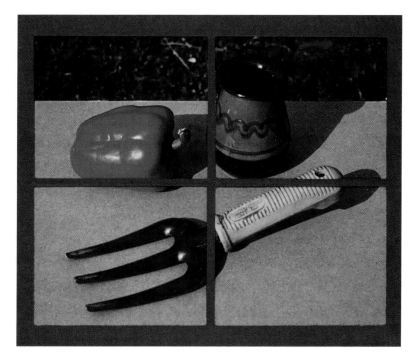

Fig 3.1 (c) Cut the clutter. Squint. This simplifies what you see before you.

Take another look. Does the arrangement jar in any way, or feel uncomfortable to the eye? I don't believe that composing a picture is something to be learned intellectually. We just know instinctively when something doesn't look right.

Consider the negative shape. This can solve the problem of an unbalanced composition.

The negative shape is the background and the foreground surrounding the main objects. This is as important as the objects themselves. Ask yourself whether there is too much negative shape to one side, or whether there is too little. Are the objects too close together, not allowing enough negative space between? Try moving the objects – or yourself – in order to alter the negative shape. Try laying the pot on its side, or point the fruit in a different direction. Play around with the objects until you feel you have achieved a certain balance in your composition.

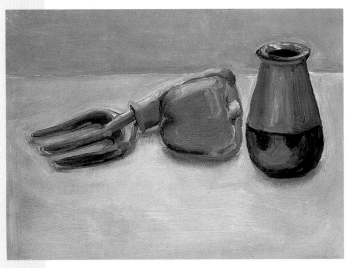

Fig 3.2 (a) The composition is too heavy on one side, leaving too much negative shape to the left.

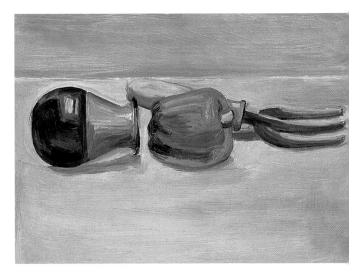

Fig 3.2 (b) The composition is too flat, leaving too much negative space below and above.

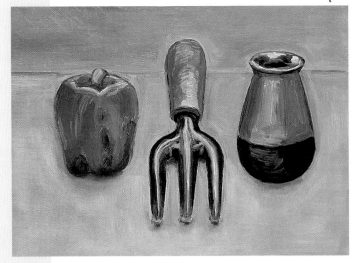

Fig 3.2 (c) The composition doesn't look natural. The objects are all pointing the same way.

See light and tone as part of the composition. Take a look at Figs 3.3 (a) and (b). The two photographs contain identical objects in the same arrangement – yet they look different. This is because, in sunlight, the shadows appear as solid as the objects. Carefully rotate the board and orientate yourself with the setting. Notice how the direction of the light affects the objects and the composition.

With anything you decide to do in the garden, if you keep in mind what you have just learned in this chapter – the composition, the negative shapes and the light – many problems can be avoided.

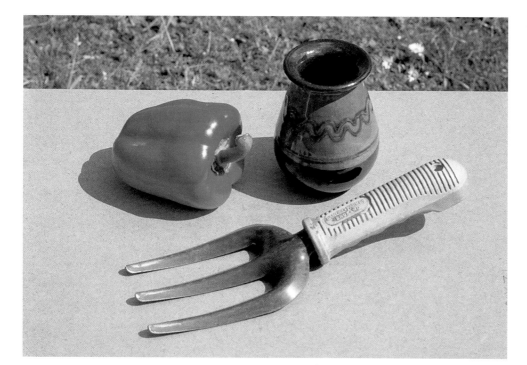

Fig 3.3 (a)

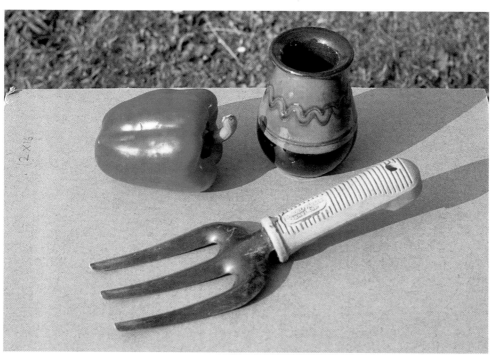

Fig 3.3 (b)

Fig 3.3 (a) and (b) The two pictures comprise the same arrangement, yet they appear to have subtle differences. This is because the light is coming from different directions. Light and shade are as solid to the eye as the objects themselves. Consider the lighting of the objects when considering your composition.

The sketch

If you are as keen as I am to begin painting, then the viewfinder can be invaluable. It speeds up the drawing time and cuts down on backtracking over corrections.

Close one eye and look through the viewfinder. You will discover that the proportion of the window equals the sizes I have recommended for your painting supports (see Chapter 1, page 15). If you lightly draw a cross in the centre of your support, it will correspond with the cross within the window.

The beauty of using the viewfinder as a drawing aid, is that you will be able to view the positioning of the objects before you even pick up a pencil. In this way, your drawing will always end up correctly positioned on the support.

Once you have decided on your view, make a mental note of the position of the window in relation to the view. This is essential. Keep this in mind throughout your drawing.

> ## Tip
> Pencil in your sketch lightly at first. Faint lines are easier to erase. Once the first key lines have been correctly worked out, you can use darker, more definite marks. This prevents a messy drawing.

Fig 3.4 (a) In my sketch, the corner of the pot passes over the intersection of the cross. In the same way, the edges of the table pass out of the picture via the horizontal line. These points have been plotted on the sketch by using crosses. By holding the viewfinder as still as possible, and keeping the plots in place, I made my first key lines – the highest point of the pot, the lowest point of the fork, the top and bottom of the table.

Fig 3.4 (b) I built upon these key lines by joining them up. Keep in mind how the objects relate to one another while you do this. I sketched the outline of the pepper and the pot and blocked in the fork.

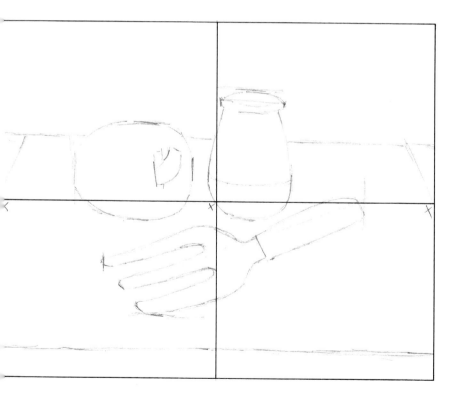

Fig 3.4 (c) I made more definite marks and filled in as much detail as I could, using the viewfinder.

Sketching in this way will feel like piecing together a jigsaw puzzle, starting off with the large pieces, and working down to the small ones.

Measuring the objects

There will come a point when the viewfinder will become too crude to be of use as a drawing aid. In some cases, using the naked eye will be sufficient to fill in the rest of the sketch. At other times, however, you may need to measure what is in front of you.

Close one eye and focus on an object. In Fig 3.5, below, I focused on the pepper. Hold your pencil out in front of you and lock your elbow. Line the lead of the pencil with the edge of the object and then run your finger along the edge of the pencil until you have found its width. I found that the width of my pepper equalled the height of the pot. This key measurement was recorded in my sketch.

In the same way, search for another measurement within the composition. Record it on your sketch if it relates in some way to your key measurement - is it, for example, equal to it or half of it?

Fig 3.5 When measuring the objects, keep your elbow locked each time you take a measurement. This ensures consistency.

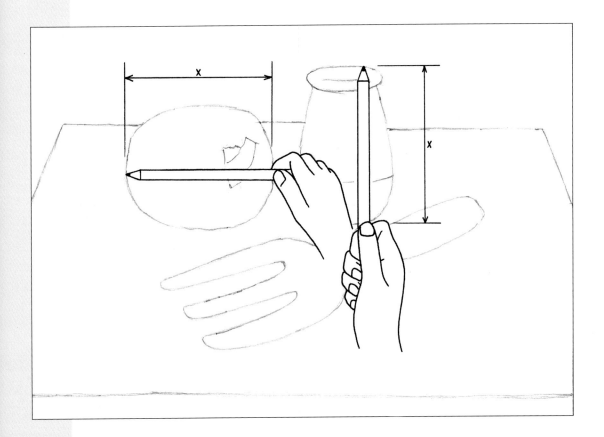

Sometimes, it may be necessary to find a another key measurement if the one you have found cannot be used throughout the sketch. Keep your elbow locked each time you measure. This ensures consistency in your sketch. Try not to alter the key lines. If something doesn't fit, measure it again. Rub out, if necessary.

Be as accurate as you can, but don't concern yourself over millimetres. This is not a technical drawing. Detail is not essential either. Keep your lines loose and take your time.

Eventually, you will find your own system of drawing. You will also find you will improve with practice.

Applying the paint

Fig 3.6 (a) Firstly, I transferred my sketch onto the primed MDF.

Fig 3.6 (b) I then applied a neutral acrylic wash, consisting of pthalo blue and burnt sienna. The wash is thin enough for the pencil lines to show through.

Now take a good look at the objects in front of you. These objects are now a series of colour shapes and tonal areas. Strip away labels and preconceptions. See the objects as though you have never seen them before.

When it comes to recording what you see before you, speed is not always of the essence. It is about observation. Simplify with half-closed eyes. Pick out the larger tonal areas first.

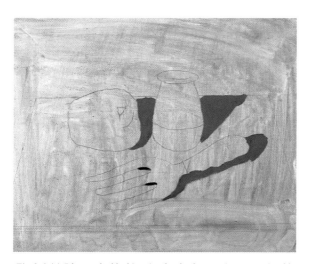

Fig 3.6 (c) I began by blocking in the shadows, using a no. 3 sable. I mixed ultramarine, permanent rose and a little white. Beautiful dark shades can be achieved with this mix.

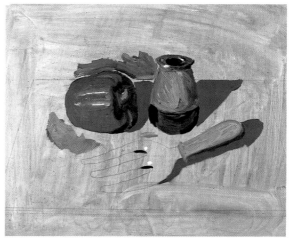

Fig 3.6 (d) Next, the pepper. I mixed plenty of cadmium red and a dab of permanent rose, again, with a no. 3 sable. The pot was completed in the same way by mixing burnt sienna and cadmium yellow.

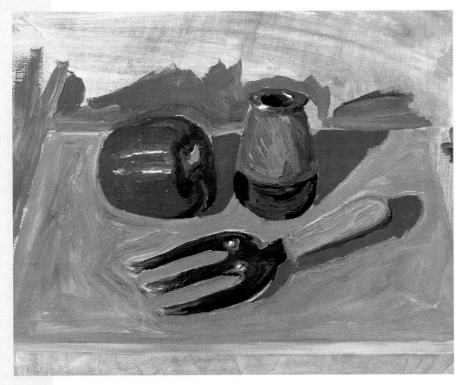

Fig 3.6 (e) For the table top, I mixed various amounts of white with burnt sienna and cadmium yellow. For the background, lemon yellow, pthalo blue and white. I applied both mixtures with separate no. 6 bristle brushes. Record the colours as accurately as you can, but don't worry if they are not spot on. You can edit later.

If you are painting on a sunny day, as I have, one piece of advice. Once you have recorded the shadows, leave them. The shadows will change before you finish the painting. This happens no matter how quickly the painting is done. You can read more about light and shadow in Chapter 6 (page 73).

Pile the paint on if you want to. Be brisk, too. Over-blending, I find, can take the freshness from a painting. Leave the brush marks in and let the underpaint show between – you don't have to cover all the areas laboriously.

At this point, I got up and stood about 3 metres (10 feet) from my painting. Standing away from your painting can clarify whether the lights and the darks are of the correct shape and of the correct tonal values.

Keep checking how the painting looks as a whole and concentrate only on those things that can be seen from 3 metres (10 feet) away or more. Something that may niggle you at a paintbrush's distance, may not be noticeable when you stand away from the painting. Only then, will the more important things become apparent. Alter only what is necessary.

To finish, I added definition to the objects and did some general tidying up. I used a no. 6 sable brush, loaded with white. I dragged the white across the rim of the pot and on the pepper. With a clean no. 6 sable, I mixed permanent rose with ultramarine and added definition to the darkest areas.

Refining the highlights and shadows are often the final touches that bring the painting to life.

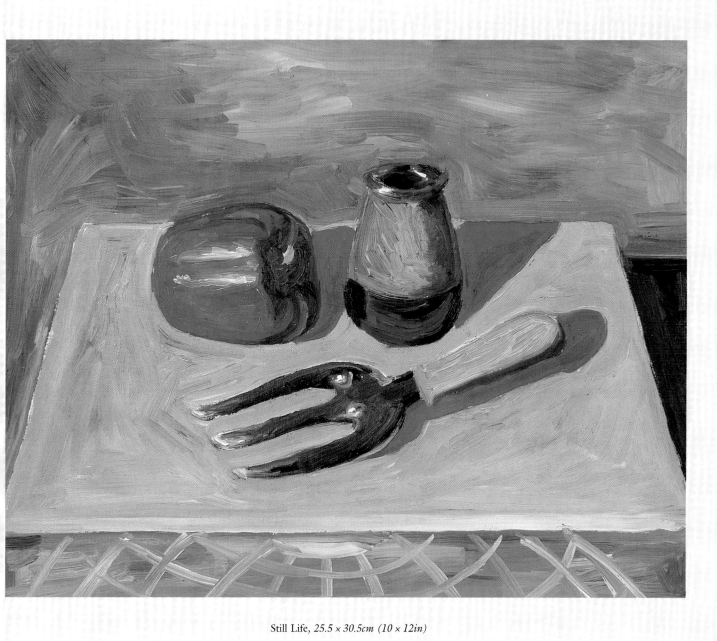

Still Life, *25.5 × 30.5cm (10 × 12in)*

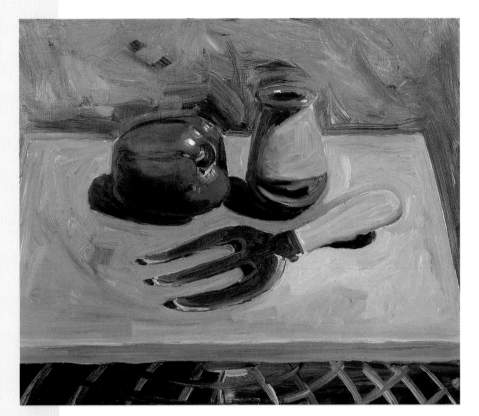

Fig 3.7 (a) This oil sketch was completed earlier in the day. The same method was used.

Fig 3.7 (b) Insects may occasionally alight on your painting. Don't be tempted to pick them off, or you will risk ruining your work. Wait until the paint is thoroughly dry, and they should brush off quite easily.

A word of encouragement

There may come a time when you will throw down your brushes and say to yourself, 'This is not for me. I don't have "the gift".' But to give up at the first hurdle would be a shame. In many ways, conveying your perception of the world in an oil painting is like using another language: the language of line, colour and tone. The complexity of the English language is remarkable, yet we take it for granted. We utilize it without thought, forgetting that more than a little practice was necessary at first.

Painting is no different. Give yourself time. Practise. You will improve. But don't be disheartened if that first hurdle seems overwhelming. This is a sign that you have never come this far before. Take a break. Go for a walk. Put away your paints for another day. Don't say 'never again' just yet.

You will find that a break from painting is vital to learning, too. Unconsciously, you will be working on that hurdle, searching for a way through. We all learn through frustration – even artists.

Chapter 4

The living backdrop

The garden can broadly be divided into two parts: the green and the non-green. Green is the living fabric of the garden, the definer of man-made objects. Non-green is the inanimate, the antithesis of nature. The two can be used to interplay with one another. This is ultimately what painting in the garden is about.

Non-green will be examined in more detail in the following chapter. For now, let us examine this most abundant colour.

The question of greens

More has been written about this colour than any other. It has the reputation of being unpredictable in its mixes, difficult to capture, a spoiler of an otherwise good painting. Green is the most prevalent colour in nature. Logic follows that there is no getting away from greens in the garden.

A colour-blindness to green is always a danger. In such a green-dominated environment, it becomes easy to fall victim to the syndrome of 'green-convenience' – the view that this colour is simply a background for flowers or a gap-filler in the foreground. It is only when nature's greens are examined more closely that the complexity of this colour is realized.

From the colour wheel shown in Chapter 1 (pages 18–19), blue and yellow would appear to be all we need to know about greens. But some blues and yellows produce a mud colour rather than green; others produce greens too synthetic to be natural. Consistently using the same blue and yellow throughout a painting will produce a rather flat and artificial representation of chlorophyll. Beautifully painted subjects in the garden, therefore, will not look good against a backdrop of unconvincing green. So without further ado, let us go back to basics and break down green into its basic parts.

Blues and yellows

We have seen in Chapter 1 that the primary colours of light do not truly exist in pigments. The brightest, cleanest yellow will be biased – even in the smallest way – towards green or red. Similarly, any given blue will be biased towards violet or green. This is why the palette I have recommended contains two blues and two yellows.

Cadmium yellow (pale) is the closest pigment to the primary yellow found in light. However, this yellow is slightly biased towards red, giving it a warm, orange glow. It is an opaque, rich yellow and will produce warm greens. Having a slight red bias, it can also produce muddy greens. Suggested uses for this yellow are autumn colours and sunlit foliage, late on a summer's afternoon.

Lemon yellow is the opposing yellow to cadmium yellow. This yellow is biased towards the green spectrum. It is therefore cooler, fresher and more acidic. This yellow will produce clean mixes of greens and is therefore suited to early spring colours and young evergreen leaves. Lemon yellow is transparent in nature and requires titanium white to give it body. Because of this, lemon yellow is easily contaminated by another colour.

Pthalo blue is the closest blue to the primary blue. This blue is slightly tilted towards the green spectrum. Pthalo blue is a sharp, cold and powerful pigment and will produce sharp, cool greens – particularly when mixed with lemon yellow. Being so dark, it often requires a little white. For this reason, this blue is ideal for deepening greens. It is also good for evergreen foliage, such as pine.

Ultramarine blue is the opposing blue to pthalo blue, which means that it is biased towards the violet spectrum. Ultramarine is a warm, transparent blue and will produce warm greens. It is ideal for sky reflections on foliage and for the bluish haze in front of distant trees. Be warned, though, that ultramarine mixed with cadmium yellow will produce the muddiest of greens, since both are biased towards the red spectrum.

Why viridian?

The two yellows and the two blues just described represent the four corners of the green spectrum. A red-yellow, a green-yellow, a violet-blue and a green-blue. These colours will produce warm greens, cool greens, lush greens and fresh greens. Why, you may ask, is a tube of viridian necessary?

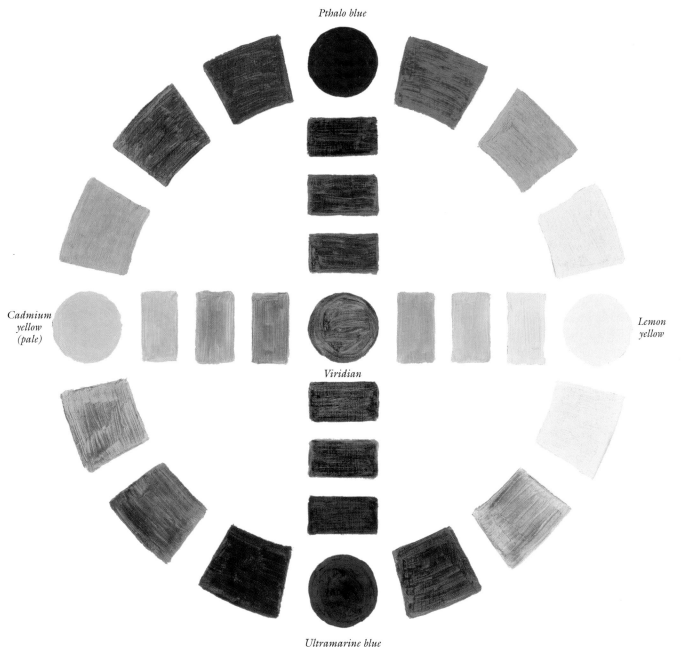

Fig 4.1 The green wheel

Pthalo blue

Cadmium yellow (pale)

Lemon yellow

Viridian

Ultramarine blue

Well, if you examine the outer edge of Fig 4.1, on the previous page, you will find the greens that will result from the mixtures of these four colours. The greens are varied and interesting, but none of these mixtures comes close to the power of viridian. Viridian provides a useful base for the green palette.

On its own, viridian is a garish green, which is unsuitable for natural greens. But when mixed with another colour, it can produce the most beautiful greens. With lemon yellow, it will result in the sort of fluorescent green we see when the sun shines through leaves. When mixed with cadmium yellow, it will produce a golden green seen on chestnut trees late on a summer's afternoon. Viridian adds punch to any blue and yellow mixture. Be warned, though, not to overuse it, or its power will dominate your green mixes.

Fig 4.1 shows how the two blues, two yellows and viridian work together to produce a good base for any green you will find in the garden.

Fig 4.2 Green plus red

Green and red

Notice the point 'base for any green'. This is important to remember because the greens in the garden are not always as green as the mixtures shown in Fig 4.1.

This is where red comes in. Red will tone down, neutralize or darken green. Look carefully and you will also find that red exists in natural greens, violet-greens, crimson-greens, and orange-greens.

The five segments of Fig 4.2 (right) represent five key green mixtures. The outer rim shows these mixtures with white. The second rim in, shows these mixtures neat. The mixtures are darkened further in the third rim by introducing red, the left half of each segment with permanent rose, the other half, with cadmium red. The inner rim shows these mixtures with white.

You will see that mixing viridian and permanent rose results in a deep, luscious green found beneath evergreen shrubs. Cadmium red with ultramarine and lemon yellow makes an excellent mix for warm shadows beneath trees. Further variations on green can be achieved by adding burnt sienna or burnt umber instead of red.

Keep your mixtures simple, to avoid dirty colours and avoid mixing your colours too thoroughly on the palette. This ensures that the green retains freshness and streaks of pure colour.

The paintings *The Lawn* and *Apple Tree* contain many different greens. The adjacent diagrams, Fig 4.3 and 4.4 on the facing page, summarize the key to the mixes I have used. The pigments are listed in order of quantity, beginning with the largest. At the end of this chapter, there are demonstrations showing how these paintings were done.

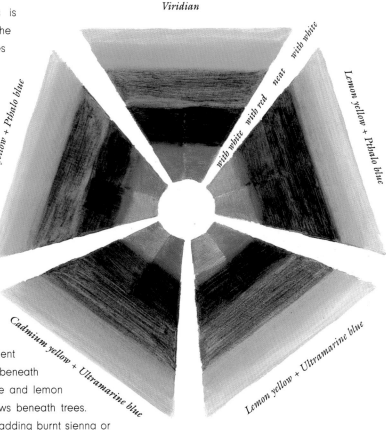

Viridian

Cadmium yellow + Pthalo blue

with white with red neat with white

Lemon yellow + Pthalo blue

Cadmium yellow + Ultramarine blue

Lemon yellow + Ultramarine blue

Greens in a nutshell

The mixes used in the paintings are suggestions only. The garden will vary. Take a good look at the green you are hoping to capture, but try not to have preconceptions. Ask yourself the following when you look at greens and your mixtures will be more accurate:

1. Which way is the green pointing? Is it towards blue, yellow or midway?
2. What is its temperature? Is it warm or cool?
3. How neutral is the green? Is it a clean green or does it contain other colours?
4. What tone is the green? Is it dark or pale?

Keep in mind how the green compares with its surroundings and it will key in to the rest of the painting. Remember, each green can be quite distinctive in the garden.

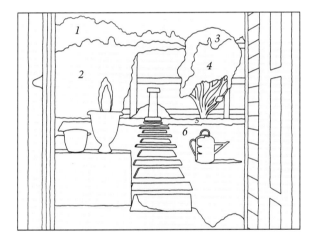

Fig 4.3 The Lawn

1. White, lemon yellow, cadmium yellow and a dab of ultramarine

2. Lemon yellow, viridian, ultramarine, with flecks of burnt umber and permanent rose

3. White, cadmium yellow and viridian

4. Cadmium yellow, ultramarine, pthalo blue and a dab of white

5. Viridian, ultramarine and a dab of white

6. Lemon yellow, white and a dab of viridian

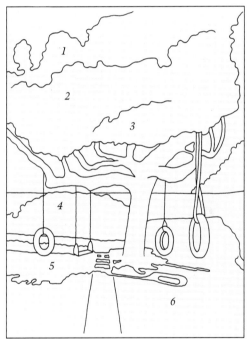

Fig 4.4 Apple Tree

1. White, lemon yellow and a dab of pthalo blue

2. Lemon yellow, pthalo blue and a dab of white

3. Pthalo blue, permanent rose and a dab of lemon yellow

4. Lemon yellow, white, cadmium yellow and a dab of pthalo blue

5. Ultramarine, permanent rose and lemon yellow

6. White, lemon yellow, a dab of cadmium yellow and a dab of pthalo blue

Making greens moody

At this point, it is worth taking a look at how greens can be manipulated further – by the colour onto which they are applied.

A white, primed board will shine through a layer of green paint like light through a slide film. An underwash of green or blue will exert a calming influence onto the overlying greens. Such an underwash is harmonious with greens and will make them restful.

The painting, *The Lawn* had such an underwash. The presence of the bluish wash is still apparent beneath the layers of green paint, even though it is almost concealed.

An underwash of red, crimson or orange will have the opposite effect on greens. Such an underwash will make greens bristle and shimmer. The reason for this is that red and green – being at opposite ends of the colour spectrum – will always try to outdo each other. In the painting, *Apple Tree,* I applied an underwash of permanent rose and cadmium yellow. This colour has created tension and contrast within the painting.

Fig 4.5 This diagram shows how the colour of the underwash can affect the overlying green. Both triangles contain identical mixes, yet the background colour affects the greens in different ways.

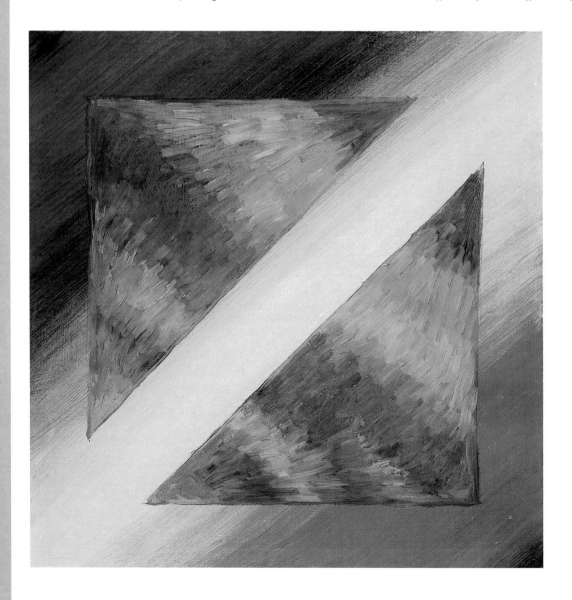

The Lawn

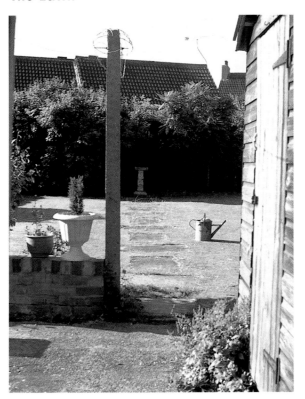

Fig 4.6 *Some of the best scenes hit you when you least expect it. Here, first thing in the morning, the oblique sun lit the grass from behind, making the lawn fluorescent. The deep shadows in the background provided the stark contrast. We are drawn further into the picture by the stepping stone path.*

Fig 4.7 *The composition and the drawing were completed later in the same week. I arranged the pots on the brick wall, and placed a watering can on the opposite side. This balanced the composition. I omitted the concrete post on the left, which served only to split the scene. Once I was happy with the setting, I sketched the scene in pencil and overlaid the lines with dark acrylic. I then applied a thin wash of pthalo blue and permanent rose acrylic over the whole drawing. This added a cool, calming influence against the subsequent greens in the painting.*

Fig 4.8 *I got up early to begin. Firstly, I blocked in the fluorescent green on the lawn. For this, I loaded a no. 8 bristle brush with white and lemon yellow. Cadmium yellow and ultramarine were introduced in places. I worked around the shape of the shadows on the left. I knew these would shrink as the sun rose.*

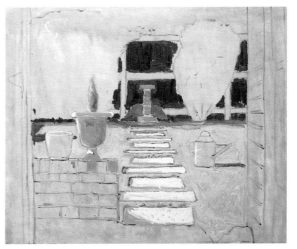

Fig 4.9 *With a clean no. 6 bristle, I moved on to the fence at the top of the garden. It was a lovely deep red, which would play off the bright lawn. I used a mixture of permanent rose and a little burnt umber and I introduced pthalo blue to the darkest areas.*

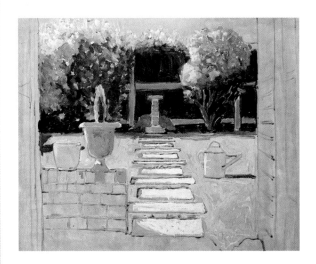

Fig 4.10 I moved briskly on to the dark greens in the background and the shadows on the lawn. I used a no. 6 sable brush for this and piled on a mixture of viridian, lemon yellow and ultramarine. I ensured the colour would be as dark as the lawn was bright, to emphasize the contrast.

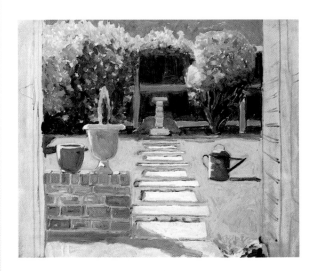

Fig 4.11 The shadows had moved quite significantly by now, but I knew the brick wall and the pots would remain in shadow for a while yet. I worked on the mortar first, by mixing cadmium yellow, burnt sienna and white. Next the bricks themselves. Cadmium red, cadmium yellow and burnt sienna were used. A little white was introduced in places. I did not concern myself with detail, but with the general colour of the wall. I blocked in the remaining objects, working on the pale areas first, like the ellipse of the pot, and the highlights of the watering can. The dark areas, such as the pot containing the cypress bush, consisted of pthalo blue and burnt umber. Nos. 3 and 6 sables were used throughout this process.

I finished off by working on the far left and right of the painting. I wanted the viewer to be led into the painting by the framing effect of the door and the side of the shed. Fiddling at the last minute is always a danger. I stood back from the painting and asked myself if certain alterations were really necessary. The board was now covered and I decided to leave it there. Notice how the pthalo blue and permanent rose underwash is still implied in the painting. The painting was begun soon after sunrise and took four hours.

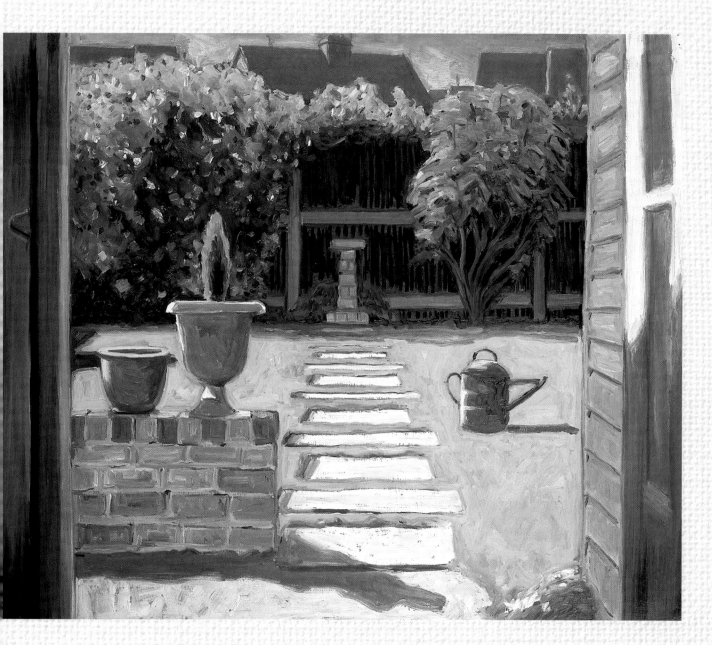

The Lawn, *51 × 61cm (20 × 24in) The key to the green mixes can be found with Fig 4.3 on page 53*

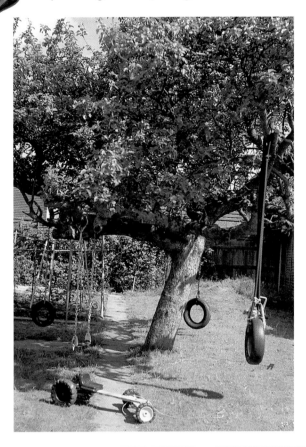

Apple Tree

Fig 4.13 *The apple tree possessed a character that only comes with age and the swings and tyres added further interest to the composition. The setting needed little alteration. I simply placed a go-kart – which was in keeping with the feel of the setting – across the path to break the dividing lines.*

Fig 4.14 *I sketched the composition one afternoon and overlaid the lines with dark acrylic. Once the line drawing was dry, I overlaid the picture with a wash that would be complementary to the greenness of the setting. This consisted of permanent rose and cadmium yellow.*

Fig 4.15 *I knew the best time to start the painting was when the shadow of the apple tree was immediately below, creating strong dapples of light and shadow against the objects. I therefore began just before noon. I worked on the shadows first by using a no. 6 sable. I purposely made the shadows very dark, by introducing permanent rose into my green mix.*

Fig 4.16 *I worked on the sunlit areas next. I was surprised to find that, despite the intensity of the sun, there was still a lot of blue on the grass. With a no. 8 bristle, I applied a pthalo blue-green mix onto this area. I ensured that the colour was still much paler than the shadow.*

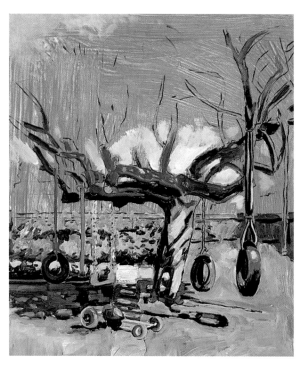

Fig 4.17 The green paint is really bristling against the red underwash. Using a no. 3 sable, I worked on the tree trunk and the tyres. These objects were almost monochrome in colour and I used burnt umber, ultramarine and pthalo blue. The brush was loaded with white for the sunlit areas. I finished off the area by pulling together the dark and pale areas of the greens.

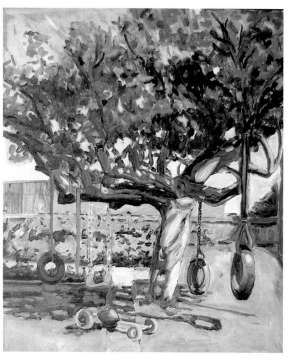

Fig 4.18 I could see that the top of the tree could potentially be a problem, as there was so much foliage to confuse and overwhelm. I decided to work on the pale areas first. I did this with a no. 6 bristle brush. I then worked on the middle greens, pulling the two together, being careful not to overwork the paint. The dark areas provided form to the top of the tree and I fed the branches through, using a no. 3 sable loaded with burnt umber and pthalo blue. I let the red underwash poke through between, as I felt this added sparkle to an otherwise large expanse of green.

Tip

When pulling together two areas of different colours, use a soft, clean brush. This will close the seam, leaving a soft dividing line. Neither colour will be noticeably contaminated by the other.

The painting had taken around four hours. Clouds had taken over by then, but the important information had already been put down. I refined the brushwork and stood away from it for a while. I was pleased with the way the red underwash added heat to the painting, reflecting the temperature of the day.

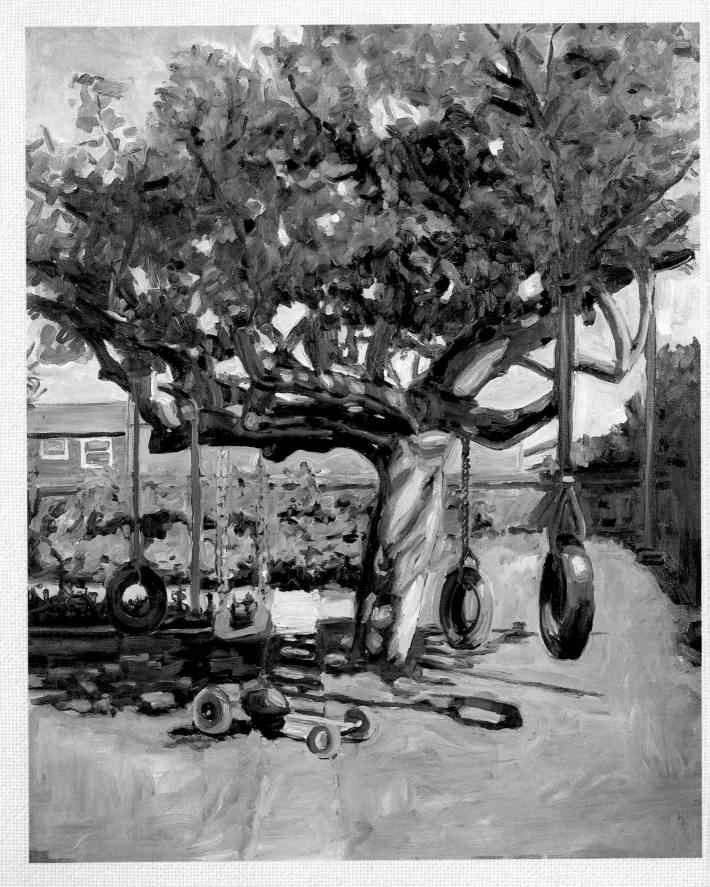

Apple Tree, 51 × 61cm (20 × 24in). The key to the green mixes can be found with Fig 4.4 on page 53

Chapter 5

Structures within the garden

In the previous chapter we have examined greens and the various forms in which they can be found. In this chapter, we will see how the introduction of man-made objects can add contrast to these natural forms.

Man-made objects provide the garden with a certain order. Fences, gates, brick walls, windows, patios, paths, steps, bird baths, trellises and sheds – these are a few of the things that give structure to the garden. Their straight lines add depth, space and perspective. They can also be used to guide the eye and to provide a focal point.

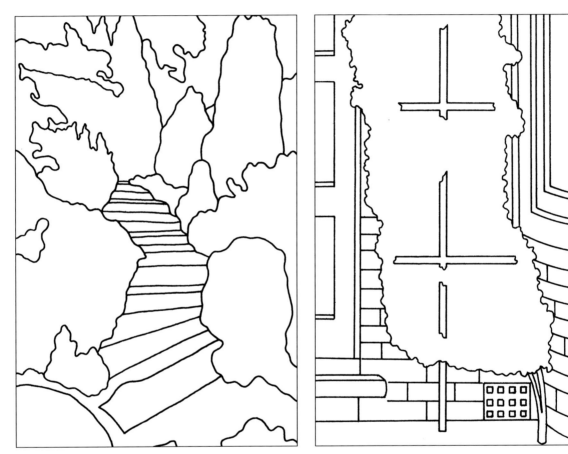

Fig 5.1 This diagram depicts steps leading through foliage. This is an example of how man-made structures can be used to lead the eye towards a certain point within the composition.

Fig 5.2 Straight lines can also be used to provide contrast to a composition comprising mainly of irregular forms. The clematis provides erratic shapes; the door and window provide the order.

Perspective

When incorporating man-made things, it is worth remembering that they usually adhere to certain rules.

Every straight edge has a vanishing point. This means that, if that straight edge were to continue for ever, it would eventually disappear at a certain point on the horizon. A basic shape, such as a bird box, possesses four such lines that zoom away from the viewer. These four lines would eventually meet at the same point on the horizon. Calculating the vanishing point is a basic way of determining angles.

In Fig 5.3, below, we can see that angles are affected by the distance from which they are viewed. If you were to stand a metre or so (a few feet) from the bird box, the angles would appear steep. Stand 6 metres (20ft) or more from the bird box and the angles would appear flatter. The height at which you viewed the bird box would also affect the angles. Notice how, irrespective of the height at which you view any object, the vanishing point is always at eye level.

Fig 5.3 These two bird boxes are viewed from below. The angles slope downwards, because the vanishing point is situated below the bird box. The angles of the bird box on the left slope off more steeply because the viewer is nearby. The angles of the bird box on the right slope downwards more gently, because the viewer is further away.

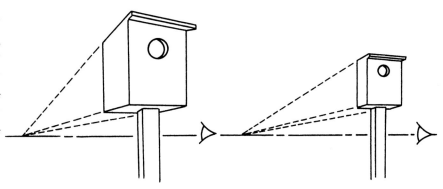

These two bird boxes are viewed from eye level. The angles converge at a vanishing point which is situated at the same level as the centre of the bird box. Again, the angles on the left converge steeply, because the viewer is nearby. The angles on the right converge more gently, because the viewer is further away.

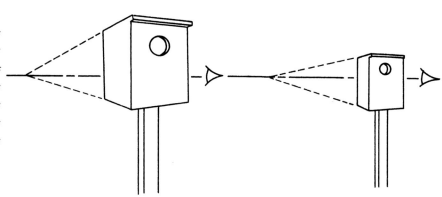

Objects at the same site can have different vanishing points.

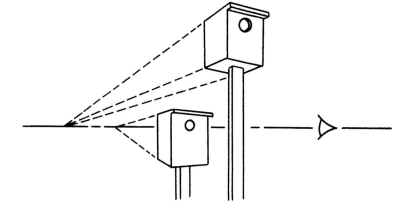

With your first sketch, take your time to get the angles and the proportion right. For example, the drawing stage of 'The Carport', shown on page 67, took an hour.

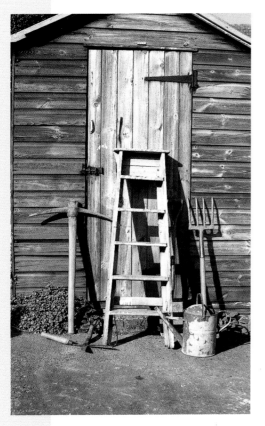

Flat areas

In the same way that a straight line will draw the eye within a mass of irregular shapes, a squiggly line will draw the eye within a mass of straight lines. In *The Shed Door*, I ensured the composition consisted mostly of geometric blocks. The weeds by the door provide the only relief.

Fig 5.5 When using straight lines in your composition, try not to aim for a technical drawing. Keep the ruler at bay, except when checking verticals and horizontals. If you cannot resist the temptation, make the habit of overdrawing the lines freehand. I did this with an acrylic-laden 00 sable.

I prepared the composition and the sketch on a separate day to the painting. A wash of burnt sienna acrylic was applied over the drawing. When a sunny morning came along, I arranged the tools against the shed door, using my sketch as reference.

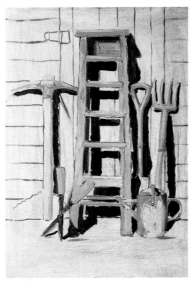

Fig 5.7 I worked on the ladder next, using pthalo blue mixed with a little lemon yellow. The watering can needed a little more lemon yellow. However, the bare metal was achieved by mixing ultramarine, white and a dab of burnt sienna. These colours, although subtle, would provide contrast against the neutrals of the other tools and the shed door. With a no. 4 bristle, I applied the neutrals by using burnt sienna, burnt umber, permanent rose and a dab of ultramarine. Varying amounts of white were used throughout.

Fig 5.6 With a no. 3 sable, I applied pthalo blue, permanent rose and burnt umber to the shadows. These were quite involved and it helped to squint my eyes, so that the shadows were broken down into their basic shapes. I found their geometric forms pleasing to the eye and they added to the sense of the scene consisting of blocks.

The butt-end of the brush

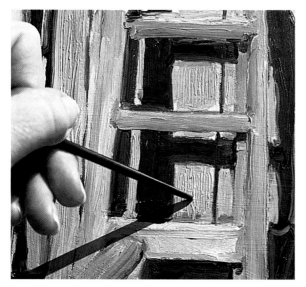

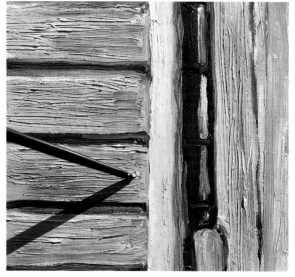

Fig 5.8 and Fig 5.9 At this point, I turned my brush on its end and scratched it into the paint. The texture that resulted resembled the feel of the wood. Scratching the paint in this way is called sgraffito. Sgraffito can be used for different effects. In this painting, the underwash revealed is of a similar colour to the overlying paint, so

emphasizing the texture of the paint. If the colour of the underwash had differed, it would have provided contrast. Different coloured underwashes will create diverse effects when using sgraffito. The final demonstration within this chapter shows how sgraffito can be used to inject vibrancy into a painting.

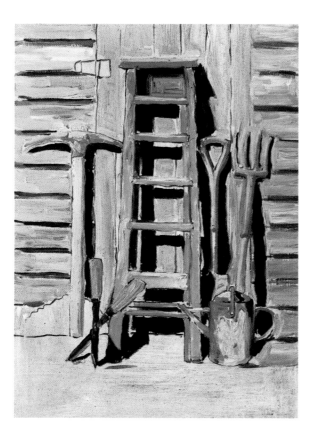

Fig 5.10 Once I had finished scratching, I added definition to the shadows. This was done by dabbing burnt umber between the planks on the shed and around the tools. With a no. 4 bristle, I then scrubbed on burnt sienna and white for the floor, while lemon yellow, white and pthalo blue were used for the weeds. This pulled the painting together.

Tip

Sgraffito can easily be removed if the marks made are unsatisfactory. With a soft, clean brush, blend the paint over the scores. This will restore the paint surface, ready for the next attempt.

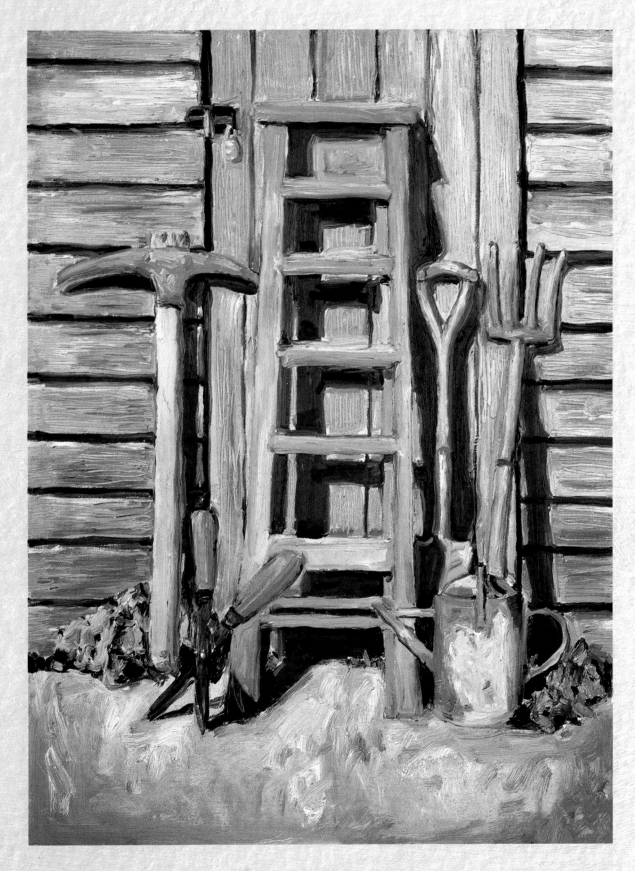

The Shed Door, *30.5 × 40.5cm (12 × 16in)*

Never too mundane

When composing your picture, it is a good idea to forget what the objects are and to view them as lines and shapes. The rest will take care of itself. No matter how mundane an object may seem, never dismiss it. A back yard, a side passageway, even a driveway can provide interesting geometric shapes.

Fig 5.12 The carport, for instance, will normally be overlooked. But on careful inspection, it has much to offer. Firstly, the carport exists on two levels – the foreground of plants, and the rear gates. The beams that connect the two emphasize the depth of the composition. On a sunny day, squares of light would form on the carport floor, thus taking the viewer deeper into the composition. The corrugated plastic roof adds further interest and you can see how the light is affected by its texture. The wheelbarrow provides the focal point. These factors make the subject matter more interesting than one would expect.

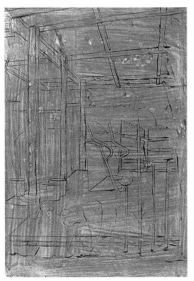

Fig 5.13 Firstly, I pencilled in the scene. This was quite a lengthy process, since there were many angles and lines to consider. If you are faced with complex subject matter, remember to use the pencil lightly at first. Don't be ashamed to use an eraser. Once the first lines have been correctly worked out, the rest will fall into place. I overlaid my sketch with dark acrylic, then applied a pthalo blue and permanent rose wash over the entire board.

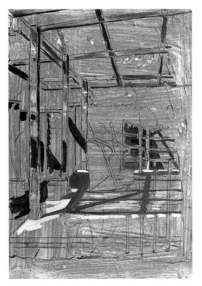

Fig 5.14 Because the beams were subject to the quickest change in light, I worked on these first, employing two no. 6 sables simultaneously. One for the darks and one for the lights. On the first sable, I mixed burnt sienna with varying amounts of ultramarine. I applied the mixture to the darks. I introduced more ultramarine into the mixture for the shadows on the carport floor. With the other sable, I mixed burnt sienna loaded with white. This was dabbed on for the lights.

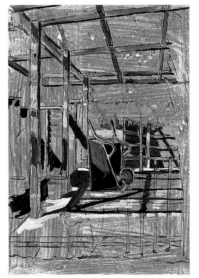

Fig 5.15 Next, I worked on the wheelbarrow, applying viridian and cadmium yellow with a no. 3 sable. I then worked on the background around this area. I loaded the mixture with lemon yellow and applied it to the field beyond the gates. I wiped the surplus paint from the brush, then introduced white and ultramarine and dabbed it to the foliage beyond. This gave the illusion of distance.

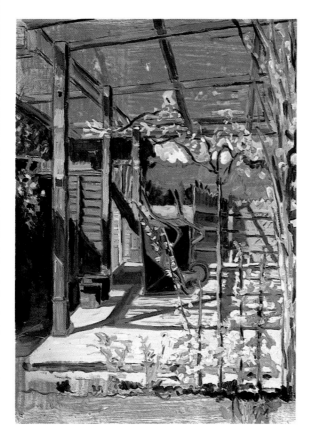

Fig 5.16 I found that I needed less reference to the scene, for I had all the information I needed. I worked on the detail in the foreground with a no. 3 and no. 6 sable. Using various bristles, I then filled in the rest of the background, working around the plants. This was of particular importance to the yellow flowers to the far left and right of the picture, which stood out against the dark background. Applying dark on top of light in alla prima does not pose a problem. But painting light on top of dark would contaminate the lighter colour.

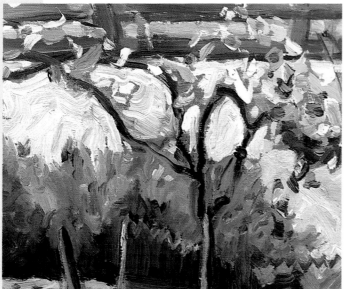

Fig 5.17 Take a close look at any seemingly complex painting, and you will see that it can be broken down into simple components. The background beyond the carport, for instance, consists of two flat colours – pale blue and deep green.

Fig 5.18 The foreground is simply a series of stakes embellished with lemon yellow and viridian green. From afar, this would appear as a complex trellis of plants.

I blocked in the sky between the beams with pthalo blue and white, then finished off the painting by reinforcing the highlights and the shadows.

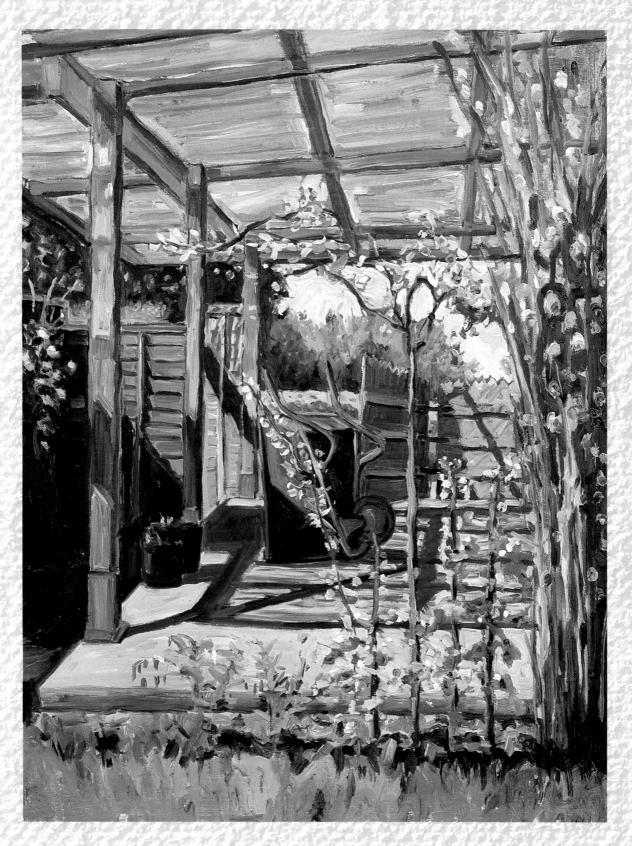

The Carport, *40.5 × 51cm (16 × 20in)*

A natural composition

Some man-made objects can be moved around, as in *The Playpen*. In this case, the composition required anything but composing. Objects had been moved out into the garden on a warm day. Subsequently, children had discarded them after spending all their energies. I was then struck by how natural and balanced the arrangement of toys looked. I made minimal adjustments, careful not to spoil the effect.

Fig 5.21 I selected a board pre-underwashed in brash colours, to create a shimmering undercurrent throughout the painting. Cadmium yellow had been used towards the top of the board; permanent rose had been introduced further down. Finally, pthalo blue and burnt sienna had been used at the bottom. I sketched the scene over the wash.

Fig 5.22 First, I blocked in the sunlit areas beyond the willow tree, applying a dab of lemon yellow mixed with viridian and plenty of white, with a no. 4 bristle brush. The tricky part behind the playpen was applied thinly. This made the application of detail on top easy, as there was little of the underpaint to contaminate the overlying colour.

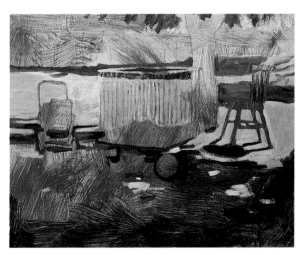

Fig 5.23 I then worked on the shaded areas, mixing pthalo blue, a touch of cadmium yellow and viridian onto a no. 6 sable. Permanent rose was introduced where the shadows were particularly deep. The remaining foreground consisted of a block of dark green, so I left this until last.

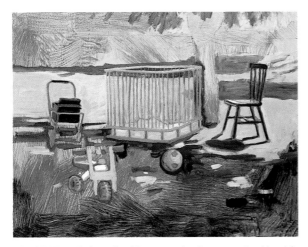

Fig 5.24 *I worked on the objects next, loading a no. 1 sable with burnt sienna and white, and applied it to the bars of the playpen. I used the other end of the brush to even out the layers of paint and to scratch off any paint that went astray. I viewed the toys as simply as possible. The pram, for instance, consists mostly of two shades of burnt sienna. The bike is made up of four basic colours. The ball is the simplest object of all.*

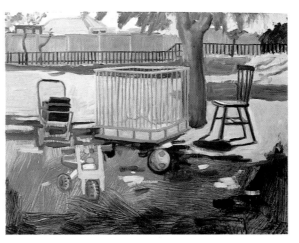

Fig 5.25 *I filled in the background, again by blocking the colours in. With a no. 3 sable, I mixed white with burnt sienna and permanent rose, then applied it onto the fence in the background. I used ultramarine and white for the fence posts. I wiped the surplus paint from the brush and loaded it with white. This was then used for the sky.*

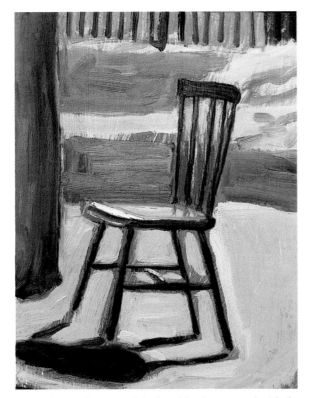

Fig 5.26 *Now that most of the board has been covered with the paint, one can see how the underwash will affect the finished painting. I allowed the underwash to be seen through the brushwork. This, as well as the sgraffito technique, helps to give the painting a vibrant look.*

Fig 5.27 *We have seen how scratching the paint in* The Shed Door *gave the painting texture (see page 65). This time, the sgraffito technique can be used to give the painting contrast. The underwash of this painting consists of different patches of colour, so scratching one area will reveal permanent rose, another will reveal cadmium yellow. This, in effect, has diversified the undercurrents within the finished painting.*

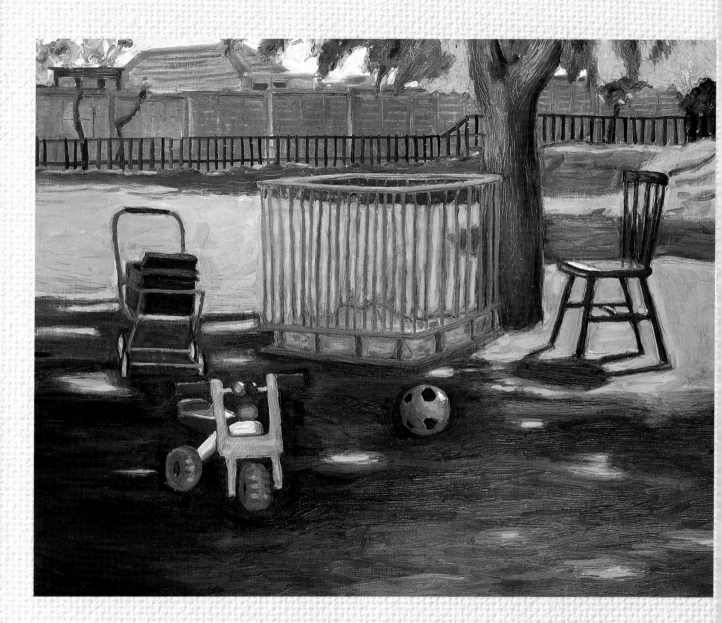

The Playpen, *30.5 × 40.5cm (12 × 16in)*

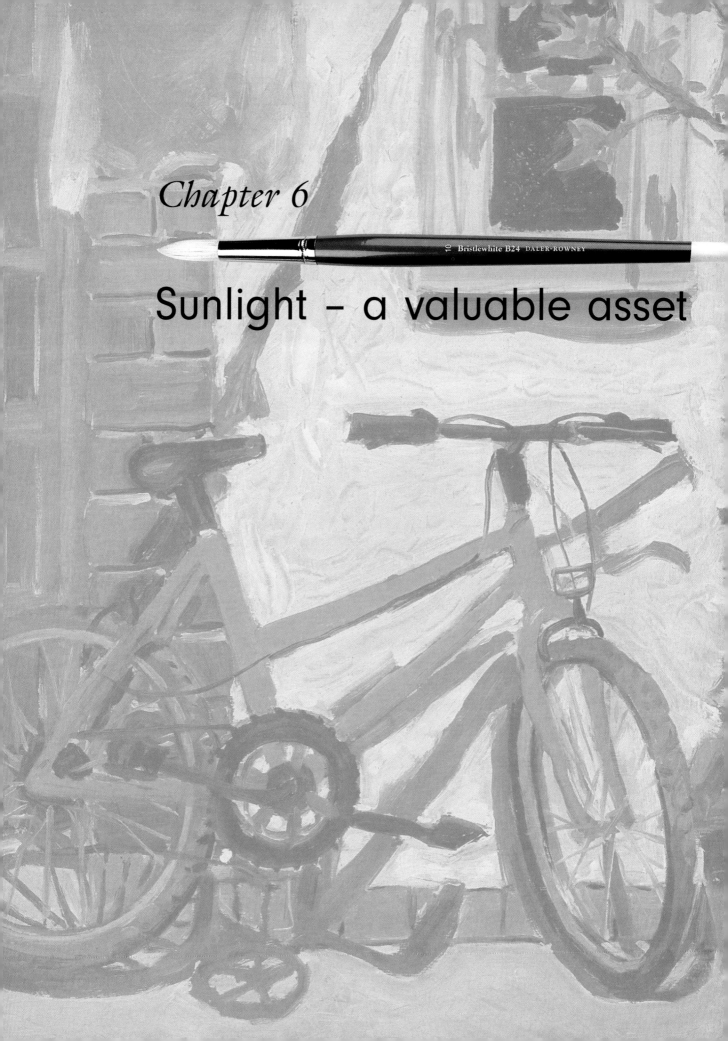

Chapter 6

Sunlight – a valuable asset

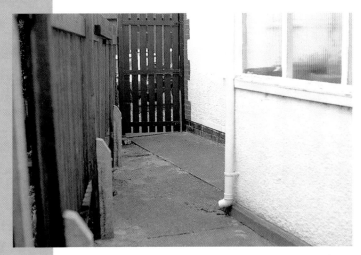

Fig 6.1 Inspiring is not a word to describe this passageway. There is no colour; no focal point and the house overshadows the area. Surely, there is nothing here to paint?

Fig 6.2 But from early evening onwards, providing the sky is clear, stripy shadows hug the walls and floor. Abstract shapes materialize and contrasts dazzle the eyes.

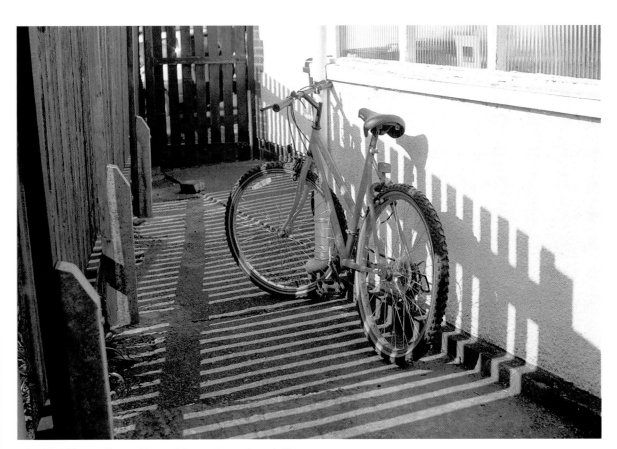

Fig 6.3 Add an ordinary object and it, too, is transformed. The original scene could hardly be more different. This is what sunlight does: it transforms. Sunlight is one of the most valuable qualities to be found in the garden.

The many facets of sunlight

These five paintings of a deck chair were completed during different times of the day. See how the sunlight can affect a scene in different ways.

The side-lit (*Fig 6.4*) is the most popular choice of sunlight within a painting. Shadows push out horizontally. Lights and darks suggest form and elsewhere, colours are pure and deep. The brightest area is the sky towards the sun; the darkest is the shadows beneath foliage, where colours can still be identified.

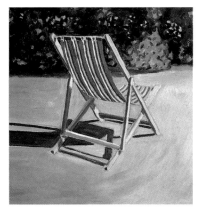

Fig 6.4. The side-lit

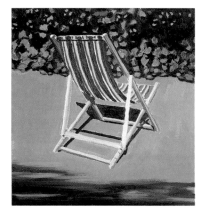

Fig 6.5. The front-lit

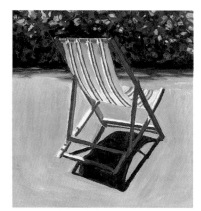

Fig 6.6. The top-lit

The palette could require vivid colours. Shadows would consist of cool colours. The sky, although loaded with white, would display a definite hue.

Fig 6.5: When the sun is behind the viewer, the objects will be at their most colourful. This is called 'colour saturation'. Foliage is at its greenest, the sky is at its bluest and flowers are at their most dazzling. Tones are more similar to one another, so the colours will appear more flat. Most shadows will be concealed behind the objects but, where they do show, they serve as punctuation throughout the scene.

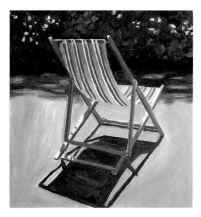

Fig 6.7. The back-lit

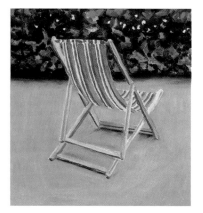

Fig 6.8. Overcast

The palette for such a view would consist mostly of bright, dense colours and little white is required from the tonal point of view. The sky would be at its deepest. A few dabs of near-black is all that is needed for the areas of shadow.

Fig 6.6: Beneath a brilliant sky, colours dazzle. Shadows puddle beneath objects and, in some places, surplus light is deflected back onto the underside of objects. This scene is more about contrast than the two described above. Some areas are very bright, others are almost black.

Depicting such a scene would require a more divided palette: brilliant colours loaded with white, or the mixtures of two to three deep colours for the darks.

Fig 6.7: Like the top-lit, everything is either very pale or very dark. The sky is at its most brilliant in front of the viewer. Detail is mostly hidden within the areas

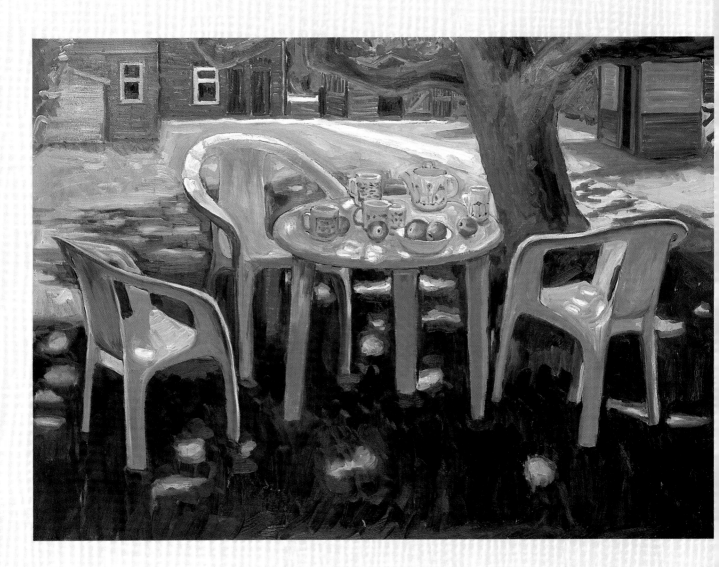

Patio Set with Apples, 50 × 70cm (19¾ × 27½in)

A more complex challenge

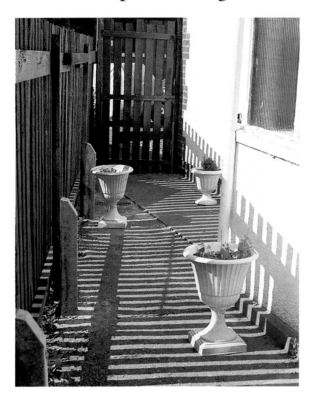

Fig 6.19 This passageway required a little more thought. Previous observations had shown that interesting shadows formed in the early evening, and remained for four hours onwards. During this time, colours would deepen, the shadows would lengthen and the sky would become rosy. I placed three pots within the composition to add dimension to the scene.

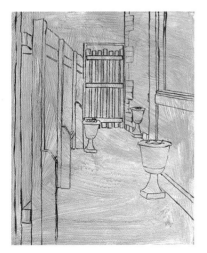

Fig 6.20 The drawing had been completed on a cloudy day. Like the earlier demonstration, The Carport (see pages 67–9), this had been indulged over, as the subject matter was rather involved. Getting the angles right is always important. Once I was happy with my sketch, I overlaid the pencil lines with dark acrylic. A burnt sienna acrylic wash was then applied over the entire board.

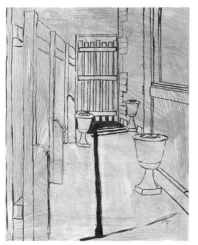

Fig 6.21 Firstly, I applied a thin layer of white, tinted with permanent rose and ultramarine. Not only did this provide a good base colour for the floor, but it also offered an oily surface onto which I could apply the numerous shadows. This reduces drag and makes the paint go further with each brushstroke, but make sure such a layer is not so thick that it contaminates the colour which will rest on top.

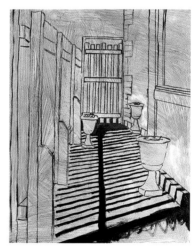

Fig 6.22 For the shadows, I mixed burnt umber, ultramarine and permanent rose. I applied this mixture to the stripes on the floor. These were crucial to the composition and would be subject to change. I endeavoured to capture the overall look of the shadows, as opposed to counting them, or trying to be too accurate.

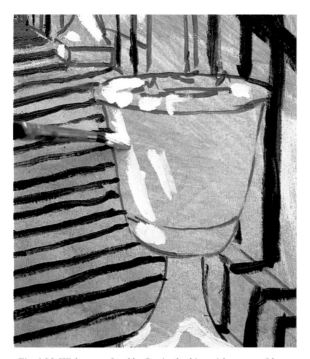

Fig 6.23 With a no. 3 sable, I mixed white with a spot of burnt sienna and dabbed this mixture onto the sunlight on the pots. I then used the original brush and dabbed on the shadows, squinting to see the shadows as shapes. In this painting, I wanted the pots to appear almost camouflaged against the stripy background.

Fig 6.24 The thin layer of underlying colour, applied to the passageway floor earlier, had served its purpose. It now appeared flat against the surrounding daubs of paint. With a clean no. 3 sable, I reinforced the colour and added texture to the paint by adding another layer. In similar fashion, I touched up the shadows, again, using a no. 3 sable.

Fig 6.25 At this point, the sun went in. However, the green fence on the left and the gate in front remained more or less the same colour, as they were within their own shadow. I blocked in the colours. The fence on the left consisted of burnt umber, pthalo blue and lemon yellow and the gate, of ultramarine, pthalo blue and permanent rose. Both were applied with a no. 6 sable.

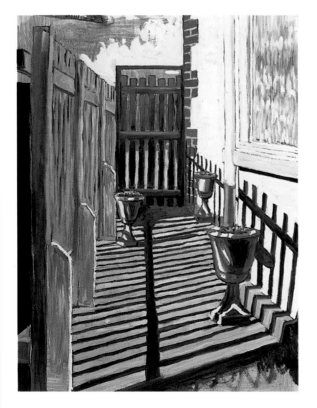

When the sun returned, I worked on the wall, the light behind the gate and the foliage in the pots. By now, the sky was rosier than when I had started. I blocked in the colour two hours later than the position of the shadows. This is the beauty of painting outdoors. It is more than capturing a moment, it is about capturing many moments, an atmosphere, an evening.

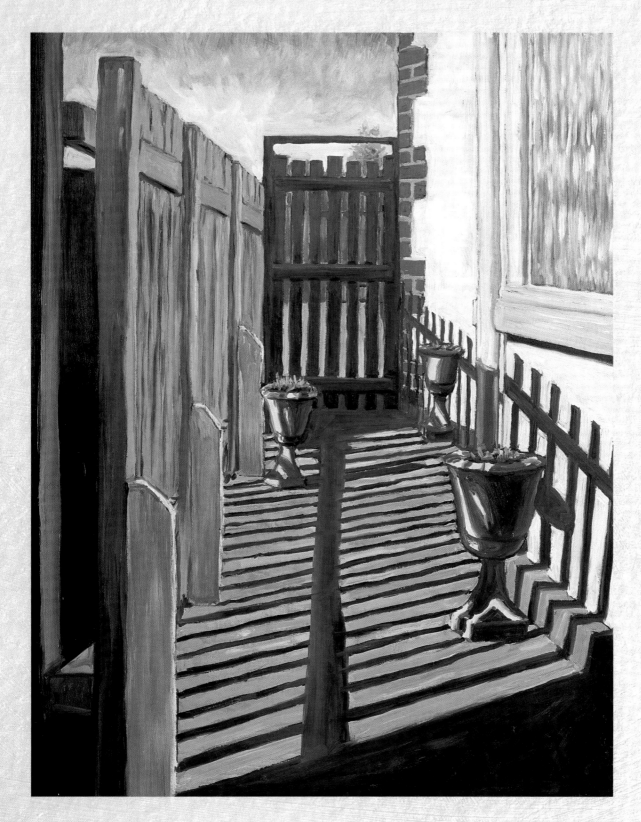

The Passageway, *40.5 × 51cm (16 × 20in)*

Ladling sunlight from a palette knife

When you decide to experiment with a sunlit scene, aim for circumstances that will allow you the time to do so.

The wall of the house in *The Bike* was almost at right angles to the movement of the sun. This meant that the wall would remain in full sun from morning to mid-afternoon. I decided to take advantage of this unchanging light, and to arrange a composition at this location. This allowed me the time to experiment with textures.

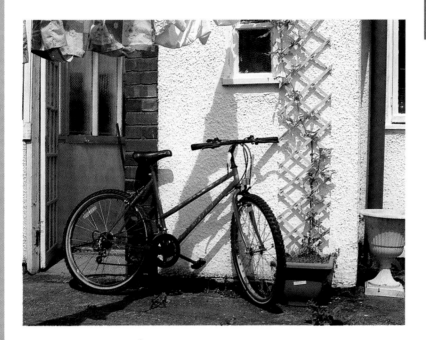

Fig 6.28 The composition had been sketched a week earlier. Bikes are never the easiest objects to draw, so I took my time to get it right. Dry weather was forecast, which meant I could leave the bike where it was, ready for the painting. Before putting the board away, I overlaid the drawing with a burnt sienna wash.

Fig 6.29 The day in question turned out hot and bright. With a no. 6 bristle, I plastered on white around the area of pebble-dashed wall. I applied this layer thinly around the intricate areas, such as the trellis. The sketch underneath can still be seen, and the thin layer of paint should not contaminate the colour to be applied on top too much.

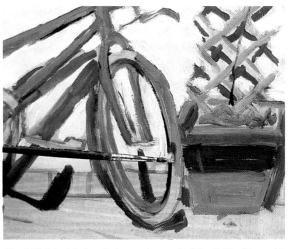

Fig 6.30 Next, I painted the shadows simultaneously. I mixed ultramarine, permanent rose and a little burnt sienna, working briskly with a no. 3 sable. With the same brush and the same mixture, I introduced white. I then blocked in the back door.

Fig 6.31 I lavished cadmium red onto the bike. I felt this would add more punch than the bike's actual colour. Deviating a little from life from time to time is sometimes necessary to make the painting work. I loaded a 00 sable with burnt umber, ultramarine and white and applied it onto the wheels.

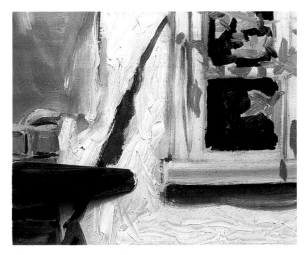

Fig 6.32 and Fig 6.33 Many areas of the painting were now covered in thick paint. I took out the palette knife and started scraping, scratching and making ridges.

The palette knife scratched through in places, revealing the burnt sienna wash beneath. The thicker areas and the ridges formed interesting textures and created a relief in the painting.

Using the palette knife to create textures adds movement and energy. The pebble dash of the wall could almost be felt. Other implements, such as an old toothbrush or a comb, can also be used to create textures.

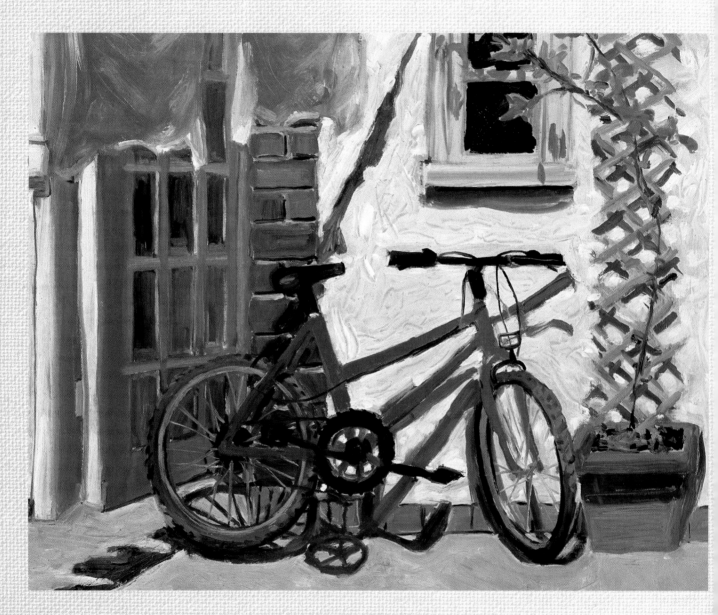

The Bike, 35.5 × 45.5cm (14 × 18in)

Chapter 7

The palette for petals

Flowers are exceedingly popular. We love to look at them, study them, read about them. The same holds true when it comes to painting them. For this reason, some people view flowers as an overused image. It is true, that even out of season, we are graced with the sight of flowers on posters, gift cards and prints. Naturally, some misconceptions can be formed from such a popular subject matter. In reality, flowers have many surprises in store.

The truth about flowers

Flowers are full of contradictions. As well as being dainty and delicate, flowers can be robust. The heads of the sunflower or the poppy, for instance, seem more like sculptures than living objects.

Take flowers from their normal setting and their bizarre forms become apparent. Isolate and magnify a rose head and its vortex of petals can be mesmerizing. Take a close look at fuchsias and you will wonder how nature ever arrived at such a shape.

Fig 7.1 Tulips *(right)*

The most dazzling of flower heads can appear dark, even on a sunny day. Take a look at this painting. The luminescent reds contain the darkest of crimsons. The golden yellows harbour greys and browns.

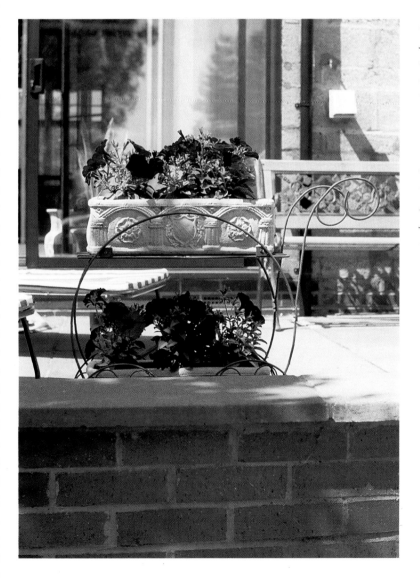

Fig 7.2 You can add to the interest of flowers by contrasting their textures against other elements. In the following demonstration, Petunias, everything within view is composed of hard surfaces: the conservatory window, the paving slabs, the brick wall, the metal bench. The container is made of moulded concrete and steel. Even the house plant in the background has a plastic quality. The petunias themselves are the only delicate feature to be found within the setting. For this reason, they provide a focal point.

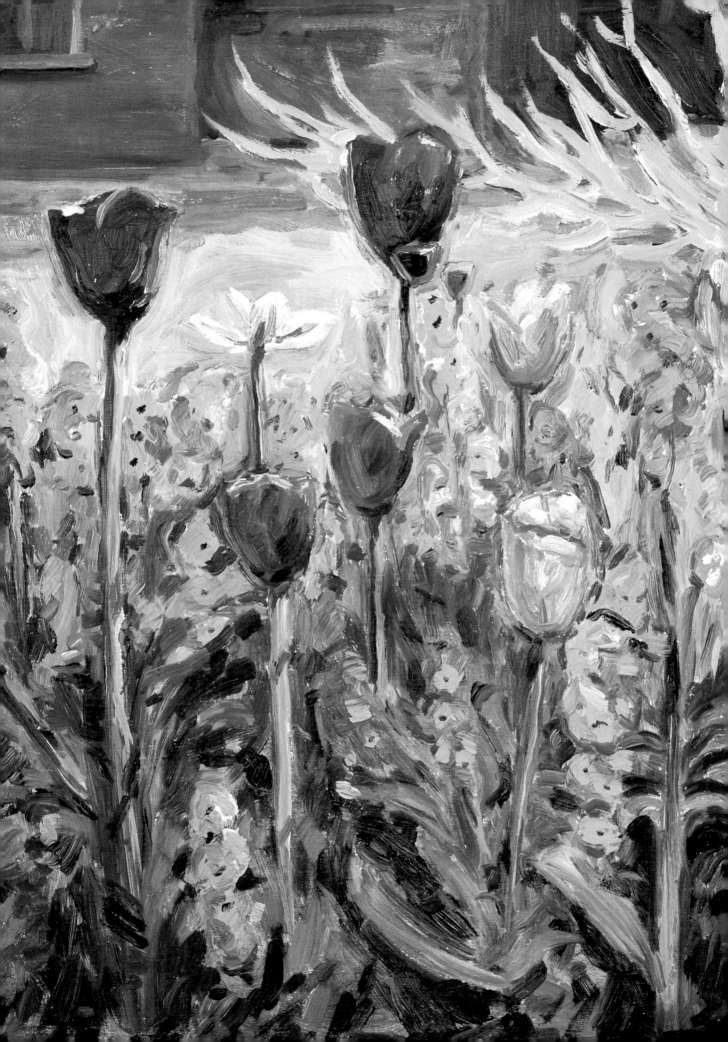

For this painting, I used medium-grain stretched canvas – the weave provides texture to the background. A smooth surface could make the flat areas of the painting appear harsh. The canvas was prepared with a coat of acrylic primer tinted with pthalo blue, as described in Chapter 2 (see pages 35 and 36).

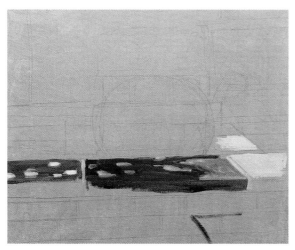

Fig 7.3 With a soft pencil, I made a basic sketch. Too much scribbling and rubbing out could risk damaging the surface of the canvas. I mixed a few drops of artists' solvent with the paint, to ensure the mixture would run into the grain of the canvas. I then mixed permanent rose, ultramarine and white and began applying the colour onto the dappled shadow resting on top of the wall. Next, I introduced more permanent rose and white and applied it to the sunlit side. The pthalo blue tinted primer has a cool, harmonious effect on the mauve tones.

Fig 7.4 The container was subject to the same change in light as the wall, so I worked on this next. The intricate moulding can be simplified by dividing the colours into three.

When trying to simplify, remember to half close your eyes. Firstly, for the palest colour, I mixed a little permanent rose, burnt sienna and loaded it with white. I applied this colour to the sunlit areas.

Secondly, for the middle shade, the mixture consisted of permanent rose, pthalo blue, white and a dab of burnt umber. I applied this colour onto the left half of the container and to a few areas to the right.

Lastly, for the darkest shadows, I mixed burnt umber and pthalo blue, dabbing this colour onto carefully selected areas. This really brings out the texture of the moulding. The same no. 3 sable was used for all the three mixtures. The previous colour was simply wiped from the brush with a rag.

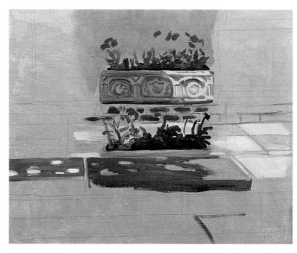

Fig 7.5 The next logical step was to block in the background area around the petunias, since this was paler in colour. This meant I could work on the petunias on top. With a no. 4 bristle brush, I mixed permanent rose, pthalo blue and white. I then wiped the surplus paint from the brush and scrubbed on a thin, but neat layer of this mixture to the conservatory window. With a no. 3 sable, I worked on the paving slabs and bricks behind the petunias.

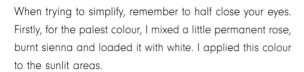

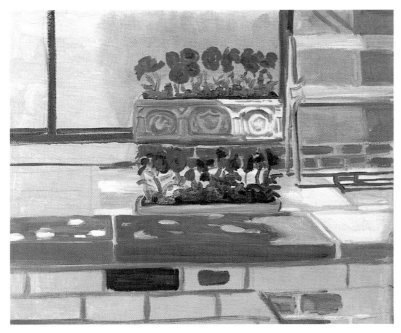

Fig 7.6 The darkest area of the painting was the petunias themselves. I mixed lemon yellow and pthalo blue, then darkened it further with permanent rose. With a no. 1 sable, I applied this colour to the greens. I introduced cadmium yellow to the sunlit areas. The flower heads were almost black in places. With a clean no. 1 sable, I mixed ultramarine and permanent rose and dabbed it onto the petals. I darkened it further with burnt umber. The final touches were provided by dabs of white and permanent rose to the highlights.

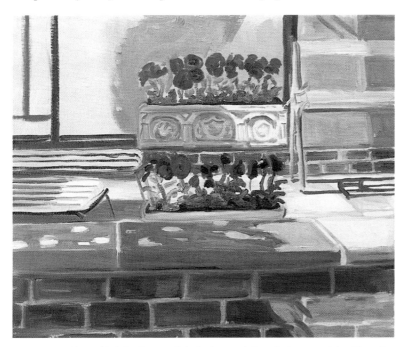

Fig 7.7 I could now block in the rest of the background. I worked on top of the thin paint around the conservatory window, introducing reflections and details within. The brick wall was straightforward. I had made colour notes earlier – a dab of permanent rose, ultramarine and white, to represent the shaded area, and a dab of cadmium red, white and burnt sienna, to represent the sunlit area. All I had to do was fill the rest in.

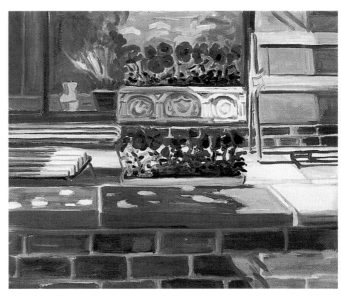

Fig 7.8 Even on a flat area of colour, the texture of the canvas can be seen. In places, the paint skids over the canvas, revealing the blue underwash. Even beneath the more opaque paint, the restful influence of the harmonious blue undercoat is implied beneath the mauves and pinks.

Fig 7.9 Detail is suggested through a few dabs of paint here and there. Highlights are added and edges are sharpened. With a clean no. 3 sable, I pulled together the background areas of colour, so that they relate to one another. This makes the painting look more complete.

Fig 7.10 Finally, the steel support. I loaded a 00 sable with white and dragged it lightly through the paint. If the semi-circle was not quite true, I could erase it by lifting off the white with a clean brush or by blending it into the colour beneath. I was satisfied with my first attempt. I made more definite marks, adding more white. Burnt umber and pthalo blue were added alongside the highlights. This gave the steel strips more form.

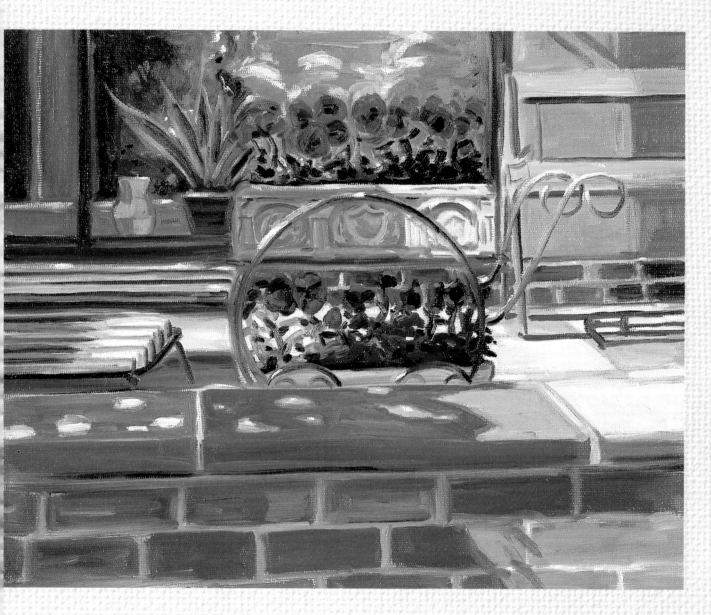

Petunias, *30.5 × 40.5cm (12 × 16in) medium-grain stretched canvas*

Flowers for a cloudy day

Sunlit flowers can provide the most dazzling colours, but sunlight is not always essential for a colourful scene. Flower heads punctuating the green can be used to lead the eye through a composition. They can also provide splashes of colour on a dull day. This can be a tremendous advantage, as an overcast day provides a relatively unchanging light.

Fig 7.13 *The surface had been prepared and a sketch overlaid in pastel pencil. How this was done is shown in Chapter 2 (see page 34).*

Fig 7.12 *In* Clematis montana, *I wanted to explore working dark to light with impasto medium. As a result, the painting took six hours to complete. I chose a bright but cloudy day, which meant the light would not change drastically throughout the duration of the painting.*

Before I could paint the clematis itself, I had to work on the background up to the foliage. This meant the clematis could be worked on top. I began with the pale colours, mixing burnt sienna, pthalo blue and white and applied this mixture to the mortar and the window sill.

Fig 7.14 Next, the bricks. I mixed varying amounts of cadmium red, permanent rose, ultramarine and burnt sienna. White and burnt umber were used separately for the tones. The paint was applied unevenly, to give the feel of the varying texture of the brickwork, which would reflect the age of the house. With the brush I had used on the mortar, I applied a pale colour to the trellis.

Fig 7.15 I was now ready to work on the clematis. I mixed pthalo blue and cadmium yellow for the darkest foliage. I applied it thinly, allowing the dark underlayer to show within the brush marks, giving the illusion of shadows within the foliage. I introduced a little lemon yellow and white to the mixture and dabbed this paler tone to carefully selected areas. This gave the foliage more form.

Impasto

Impasto medium is an alkyd-based gel that adds body to the paint. Don't be put off by the colour of the gel – it doesn't affect the colour you are mixing. Do bear in mind, though, that the gel accelerates the drying rate of the paint. Once applied, it will be touch-dry in 24 hours.

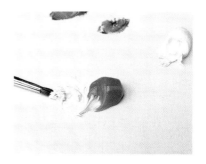

In this example, I wanted to use the impasto technique to emphasize the clematis flower heads. I mixed white with a dab of permanent rose and thickened it with a little of the gel.

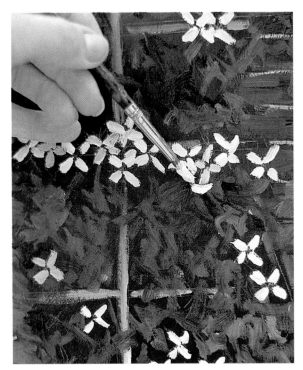

Fig 7.17 With a loaded no. 3 sable, I applied the mixture onto the areas represented by flower heads. I piled on the paint so that the paint stuck out from the surface and provided a relief effect to the painting. This made the flower heads stand out even more.

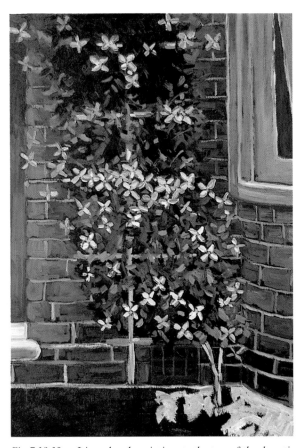

Fig 7.18 Next I introduced variations to the tone of the clematis heads. I dabbed neat permanent rose and a little ultramarine with a 00 sable around the flower heads. I then introduced more ultramarine into my mix and applied it to the more shaded flower heads, so taking the flatness from the colour of the clematis petals. Once I was happy, I worked on the door and the window, blocking in the colours with a no. 6 bristle brush.

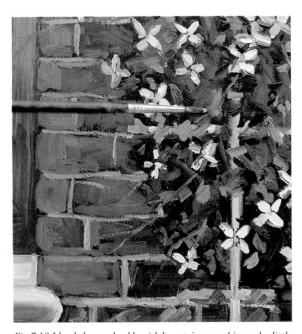

Fig 7.19 I loaded a no. 1 sable with burnt sienna, white and a little cadmium red, then mixed in a little of the gel. I dragged the mixture over the foliage, to represent the twines within the clematis. The finishing touches were provided by reinforcing the highlights and the shadows.

Tip

An alternative way of adding body to the paint is to leave surplus paint on the palette overnight. The paint will thicken as it loses some of its oily content (although some pigments will do so quicker than others) and the paint can then be used for impasto.

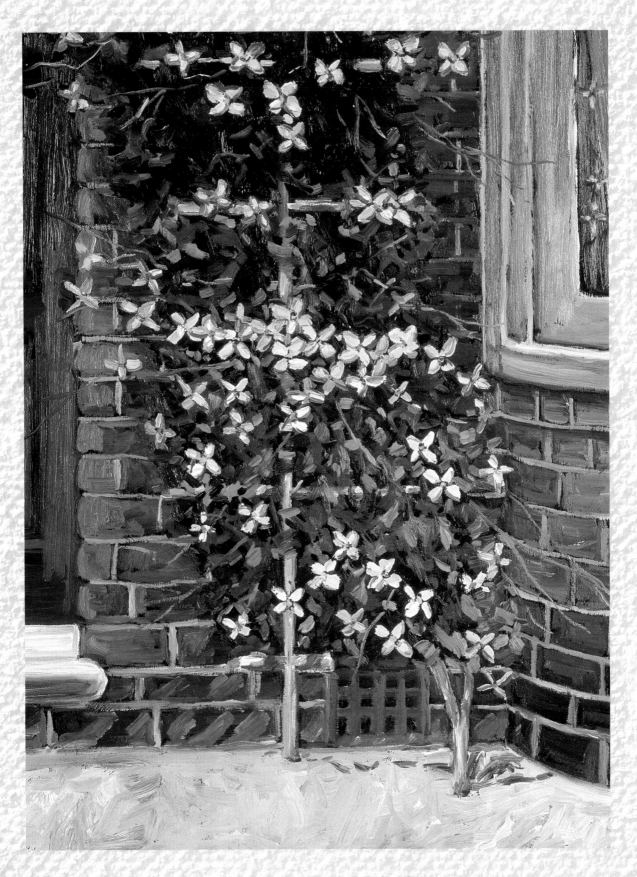

Clematis montana, *30.5 × 40.5cm (12 × 16in)*

Linseed oil

We have taken a look at how impasto medium can be used to emphasize flowers. At this point, I thought it would be appropriate to follow this up with a demonstration involving linseed oil. Linseed oil is, in many ways, the opposite to impasto medium – it thins the paint rather than thickens it; it dries slowly rather than quickly.

In *The Arbour*, varying amounts of linseed oil were used within the paint. This brings out the different textures that can be found in flowers.

The simplicity within the complex

This scene basically consists of two parts: the greens of the foliage, and the wood of the arbour. This had an effect on how I would prepare my board.

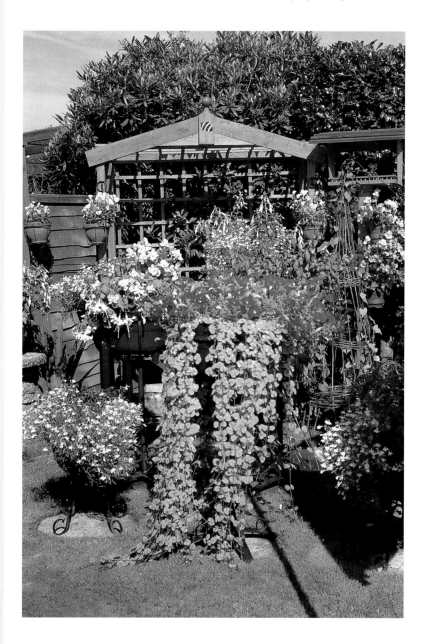

Fig 7.21 When it comes to complexity and detail, scenes such as the arbour can seem overwhelming. The secret is to examine each area in turn and break it down into two or three parts. This means filtering information.

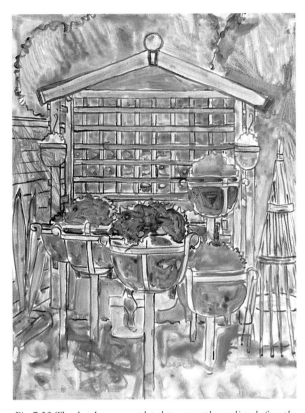

Fig 7.22 *The sketch was completed two months earlier, before the burgeoning of plants had complicated the scene. Two washes were used over the drawing: a pthalo blue wash for the area consisting of foliage, and permanent rose with cadmium yellow for the wood. The drawing was no longer an array of lines and angles, but an image that can easily be understood.*

Fig 7.23 *When I was ready to begin the painting, the scene had altered somewhat. However, the skeleton of the composition – the pots and the arbour – remained the same. I began by drizzling a little linseed oil onto the palette. This thinned the paint and made it flow. I decided to work on the foliage first, mixing cadmium yellow and pthalo blue with varying amounts of viridian.*

Fig 7.24 *Here I used a sable brush to apply the paint to the shaded area behind the arbour, using linseed oil in varying amounts to give the painting different textures. I wanted the foliage to be smooth and flat, to create a contrasting texture to the flower heads, which would be applied with neat paint.*

Tonking

When working on an intricate painting, it is easy to overwork the paint, or to apply it too thickly early on so that it becomes difficult to modify the paint on top. If you are unhappy with an area of the painting, don't wipe it off with a rag, as this will disturb the surrounding area. A technique known as 'tonking' will turn back the clock.

Fig 7.25 Firstly, place some newspaper over the area concerned. Press the paper onto the area firmly, then carefully peel it off. This will have the effect of blotting off the surplus paint. None of the surrounding paint will be smudged or disturbed.

Fig 7.26 When the paper is lifted off, the paint will come off with it. Repeat the process with a fresh piece of paper until little of the oil paint can be lifted off. A thin layer of residue paint will remain on the painting surface and this can easily be worked upon.

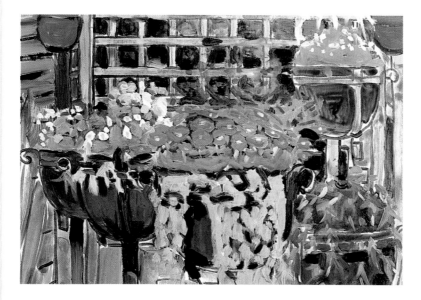

Working thin to thick

Fig 7.27 I continued with the rest of the background, introducing more linseed oil. When it was time to work on the blooms, I used a fresh brush, piling on neat paint. I mixed white and permanent rose for the pink petunias. I then mixed white with a dab of cadmium red for the fuchsias and introduced cadmium yellow and more white for the violas.

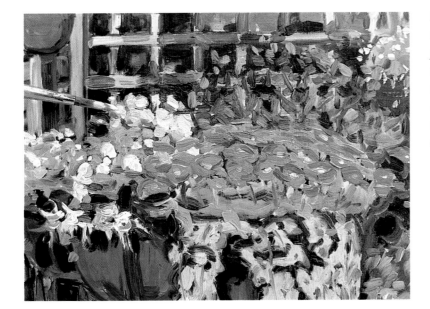

Fig 7.28 I introduced thick paint into areas of the background to give the painting a textural balance and piled more paint onto the blooms. Doing this in stages builds up the paint more effectively than doing so in one dab and the flowers now look rich against the thinner paint elsewhere.

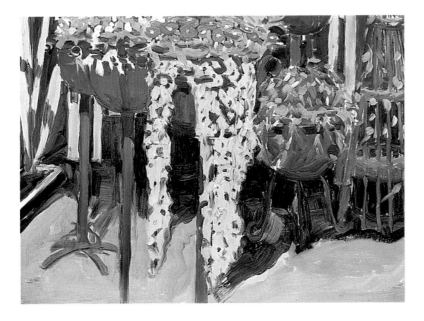

Fig 7.29 Next, I reverted to the brush which had been used for the linseed oil mixes. I mixed pthalo blue, lemon yellow, a little cadmium yellow and lots of white and applied this mixture to the lawn. Notice how the linseed oil gives a fluid quality to the shadows, creating a textural contrast between the flowers and the background.

Finally, I blocked in the sky and introduced more detail into the background. The painting took five hours to complete. As you can see from the photograph of the scene and the finished painting, the shadows had changed by then.

A flower for all seasons

Flowers can be appreciated any time of the year, even in deep winter. The final demonstration in Chapter 10 (pages 145–8) examines winter flowers against a bedroom window. The sun filtering through the glass can feel almost like summer. Sunflowers in autumn are also an intriguing subject matter, as can be seen in Chapter 8 (pages 112–16). The study of flowers, therefore, need not be confined to the warmer months.

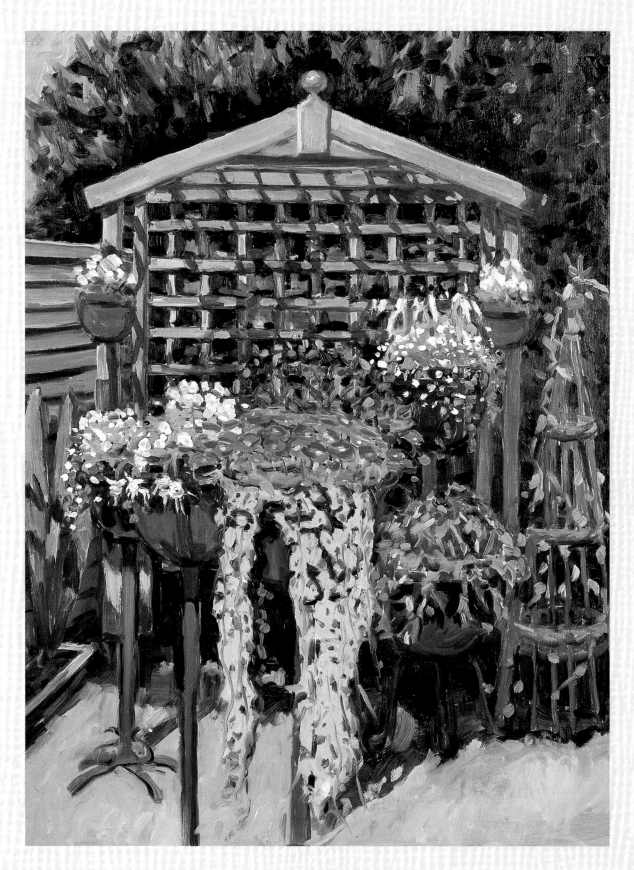

The Arbour, *30.5 × 40.5cm (12 × 16in)*

Chapter 8

Harvest time

ruit and vegetables are among the most interesting objects to be found in the garden. Not only do they offer fascinating shapes and colours, they are also edible. For this reason, a painting containing food in its raw state never fails to draw the eye. This is why the first demonstration, on strawberries, consists of a simple setting.

Fruit without fuss

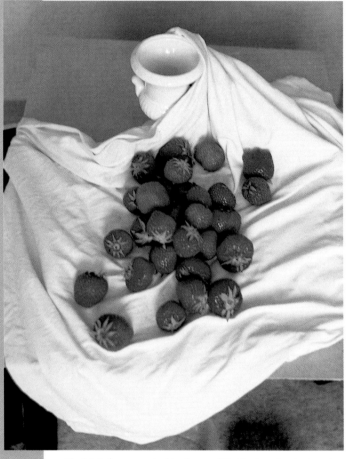

Fig 8.1 I chose a neutral background for the strawberries in order to emphasize their natural forms. As soon as they were picked, I tipped them onto a white cloth. Minimal adjustments were then made as I did not want them to appear too arranged.

Fig 8.2 I embarked on the sketch, which took 20 minutes. Time is always an issue when painting perishables. I did not bother to overlay the pencil lines with acrylic, as this would use up additional time. I moved straight on to apply a thin acrylic wash consisting of pthalo blue and a dab of permanent rose.

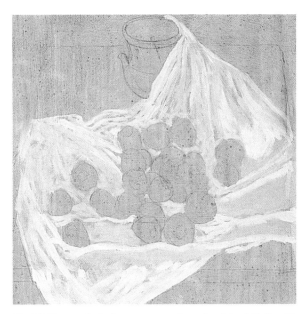

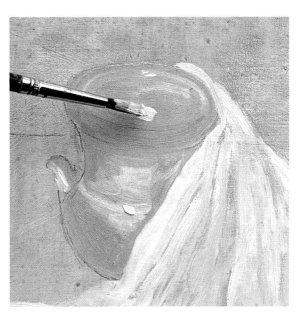

Fig 8.3 The next logical step was to work on the white cloth. I could then paint the strawberries on top. I mixed white and a dab of burnt sienna, then applied the paint in various thicknesses with a no. 3 sable brush. The thin paint reveals the underwash beneath, showing off the folds and shaded areas effectively. Brighter tones and highlights are illustrated through the opaque areas of white. Working in this way, with the paint in varying thicknesses over a darker wash, dispenses with the need to mix different colours for the tones.

Fig 8.4 With the same brush, I introduced a little more burnt sienna and applied the mixture onto the vase, introducing a dab of ultramarine for the darker areas. I wiped the brush on a rag and then dabbed on neat white for the highlights.

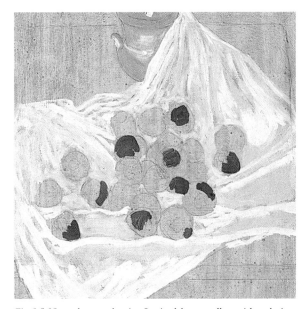

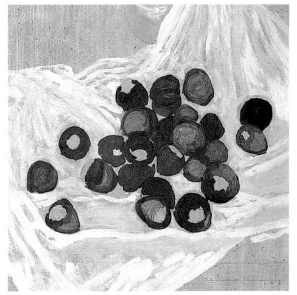

Fig 8.5 Next, the strawberries. I mixed lemon yellow with cadmium red and dabbed it onto the areas of strawberries that were still turning. Cadmium yellow was not used because the orange was rather cool and sharp and cadmium yellow would have made the mixture too warm and rich. Some strawberries were more ripe than others, therefore some were a deeper red. It seemed logical to paint progressively darker.

Fig 8.6 With the same brush, I introduced permanent rose and dabbed it around the orange-red and onto the darker strawberries. I allowed the paint to appear uneven and patchy, so that it gave texture to the strawberries and made them look more authentic. The green areas were left blank for now.

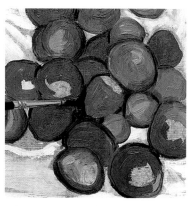

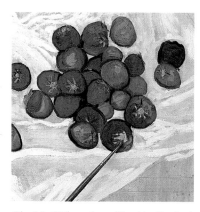

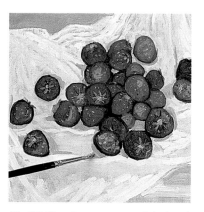

Fig 8.7 Again with the same brush, I introduced ultramarine and burnt umber into the mixture and worked the paint between the strawberries. This dark colour gave form to the fruit. I cleaned the brush and blended the areas, ensuring the finish was not too smooth, as that would mean the strawberries would end up looking artificial.

Fig 8.8 With a clean 00 sable, I mixed lemon yellow, white and a dab of pthalo blue and applied the mixture onto the green heads of the strawberries. The pigments used for the green can easily be contaminated by the surrounding red, so I wiped off any red residue from the brush each time I worked the colour on.

Fig 8.9 Now that most areas of the board were covered with the oil paint, I could see how the tonal values of the painting keyed into each other. As you can see, the white cloth now appears too washed-out beside the rich strawberries. A little adjusting was necessary, so I introduced darker areas around the strawberries, to give the impression that the strawberries were seated on top. Balance was soon achieved between the strawberries and the cloth.

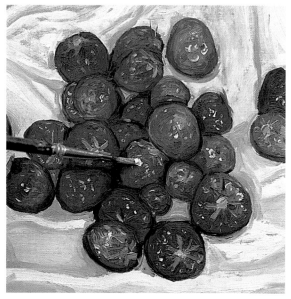

Fig 8.10 Now for a little magic. I mixed white with a little ultramarine and dabbed the mixture onto the areas of strawberries reflecting the cloth. All of a sudden, the strawberries belong to the setting. Small touches like these come from keen observation and the result is that the painting looks more convincing.

The final touches are provided by the highlights. With a clean 00 sable, I dabbed neat white onto chosen areas of the strawberries. Not all the highlights were spots of light; some were shaped like small doughnuts, so reinforcing the texture of the strawberries.

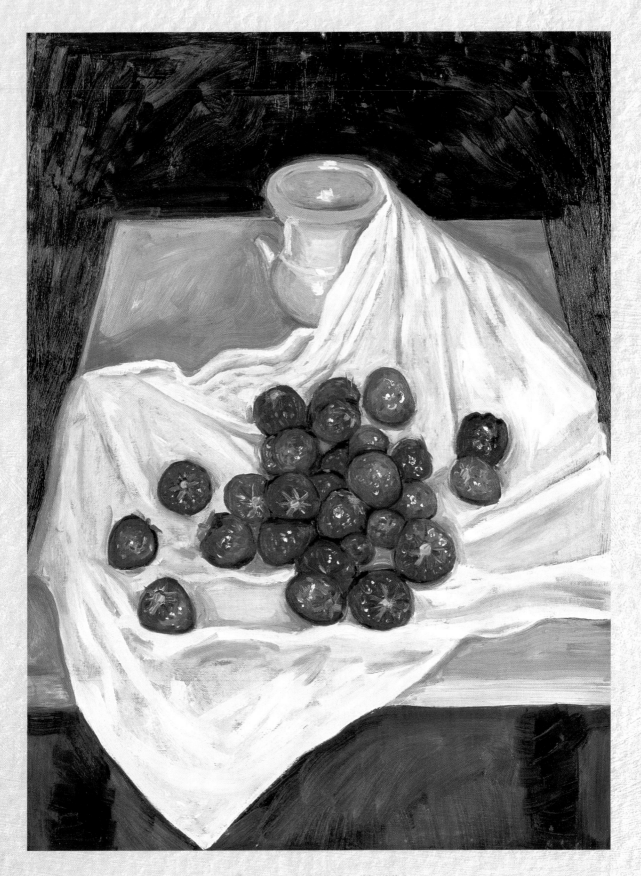

Strawberries, *30.5 × 40.5cm (12 × 16in)*

The greenhouse

Painting fruit and vegetables before they are picked has two advantages. Firstly, they will stay fresh for weeks instead of days. Secondly, you can choose at which stage of the ripening process you wish to paint.

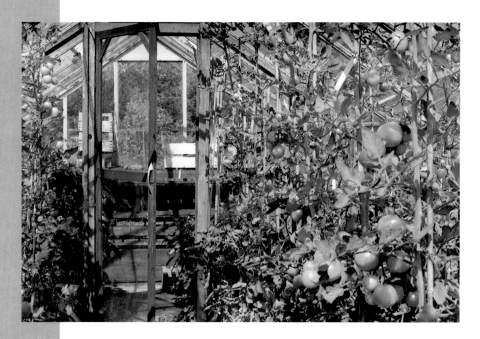

Fig 8.12 In the case of these tomato plants, I waited until they had just begun to ripen. I then had greens, yellows, oranges and reds to paint with. Late summer turned out to be the ideal time to begin my painting, as the light was good and some of the tomatoes were bright red, providing complementary splashes of colour against the greens.

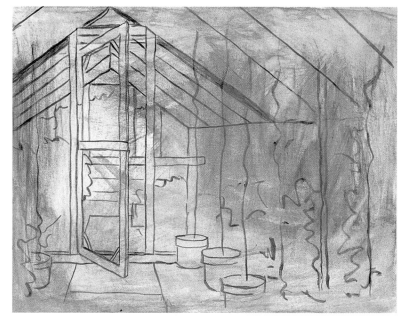

Fig 8.13 The sketch was completed on canvas-board the previous day. It was then overlaid with dark acrylic. Once this was dry, I applied a wash of permanent rose and cadmium yellow over the entire board, to provide a pleasing contrast against the blues and greens within the greenhouse setting.

Scumbling

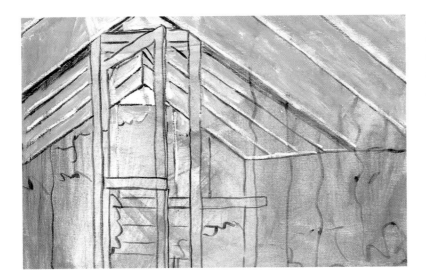

Fig 8.14 The day turned out hot, so I sat next to the open door. I began with the sky, mixing pthalo blue with white. I applied this with a no. 4 bristle, in a neat layer, allowing some of the undercoat to show though. In parts, the paint skidded over the texture of the canvas-board, revealing the underwash beneath. Applying such a broken glaze is known as 'scumbling'.

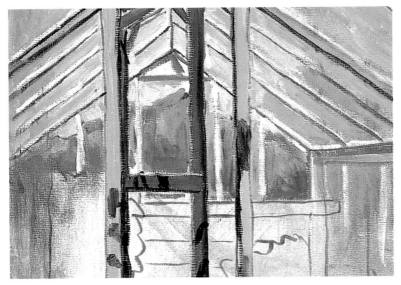

Fig 8.15 With the same brush, I introduced lemon yellow, a little cadmium yellow and a dab of ultramarine. I applied the resultant green in the same way, allowing the thickness of the pigment to vary in patches. The thin layers appeared to be located on the outside of the glass. The more opaque, deeper colours – such as the door frame – were used for the inside of the greenhouse, reinforcing the division between the exterior and the interior.

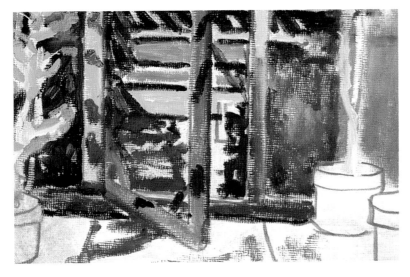

Fig 8.16 Next, I introduced burnt umber into my green mixture and blocked in the dark areas near the floor. This provided form and contrast to the objects within the greenhouse and offset the sunlit areas leading from the inner door. Establishing the tonal balance of a painting at an early stage means you can adjust how the tones key in together as the painting progresses.

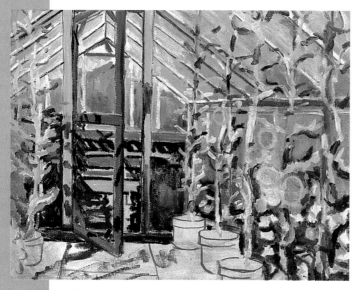

Fig 8.17 The background areas around the tomato plants had been blocked in earlier, so I could now work on top. The greenery of the tomato plants could easily overwhelm, so remember to simplify such a view through half-closed eyes, so that the detail can be implied, rather than illustrated in full. With a clean no. 3 sable, I mixed lemon yellow, white and a dab of pthalo blue, embarking on the sunlit stems first. I worked progressively darker, adding more pthalo blue, permanent rose and burnt umber into my greens. I aimed to capture the general feel of the plants, working over them simultaneously.

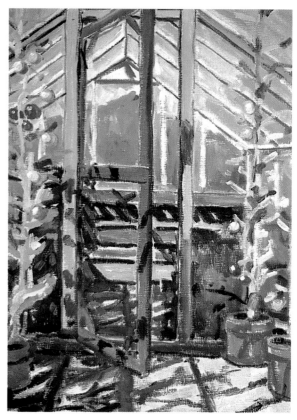

Fig 8.18 The shadows on the floor were shifting and I wanted to capture them while they were dappled. For the sunlit areas, I used a mixture of permanent rose and white. With a clean no. 3 sable, I mixed ultramarine, permanent rose and a little burnt umber. I 'scumbled' the thin, neat mixture onto the shaded areas and introduced more burnt umber around the shadows near the pots.

As you can see, a painting does not always pull together until the very last brush mark. In this case, the focal point is provided by the tomato fruit.

Fig 8.19 Now for the best bit. I picked up my 'green' brush, which had been used on the stems earlier, and wiped the old mixture onto a rag. I mixed lemon yellow, white and a dab of pthalo blue and applied the mixture onto the green tomatoes. With a clean brush, I introduced cadmium yellow and dabbed it onto the other tomatoes. Cadmium red was applied next. The tomatoes suddenly leapt out from the green and blue background. I mixed in permanent rose and dabbed it onto the ripest areas of tomato. Lastly, I dabbed on neat white from a clean sable for the highlights.

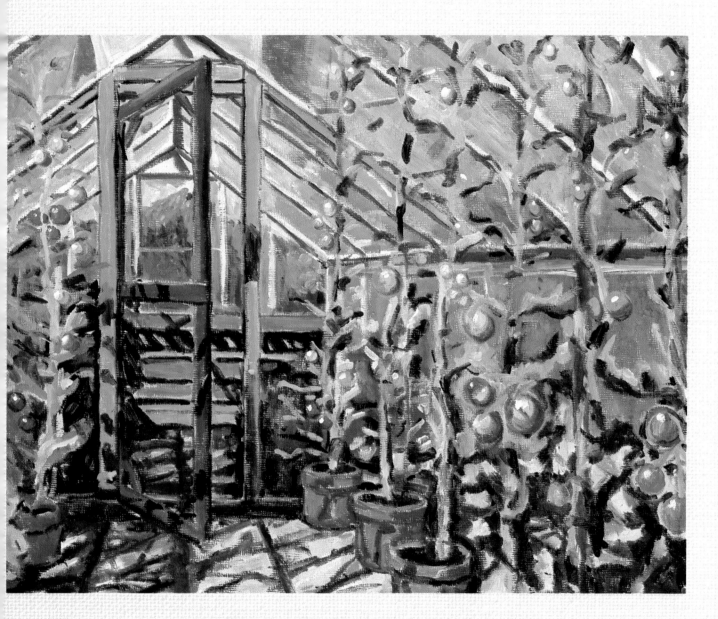

Tomato Plants, *35.5 × 45.5cm (14 × 18in) canvas-board*

The unique light of autumn

Spring and autumn lie on equal sides of the summer solstice – the day at which the sun reaches its highest point in the sky. But the quality of light produced in spring and autumn can appear very different in each season.

The light in spring harbours the paleness of winter, producing a tendency for pinks and mauves. In autumn, the light is altogether more golden. It is as if the light still possess the warmth of summer. This was the sort of light I wanted to capture in my study of sunflowers.

Fig 8.21 I positioned the sunflowers next to the shed, so that the bright yellow heads would provide stark contrast to the shed wall. To provide a further slant, I decided not only to plant the traditional yellow sunflowers, but to intersperse them with maroon ones.

Tip

When working on coarse canvas, use a stiff brush at first. This will get the paint into the weave. Doing this with a soft brush will cause unnecessary wear and tear to the brush.

The absorbing effects of coarse-grain canvas

Fig 8.22 For the painting, I used coarse-grain stretched canvas. I tinted it with a thin acrylic wash made from pthalo blu and permanent rose. I made a rudimentary sketch with a soft pencil. The morning had turned out bright and breezy – autumn was certainly in the air.

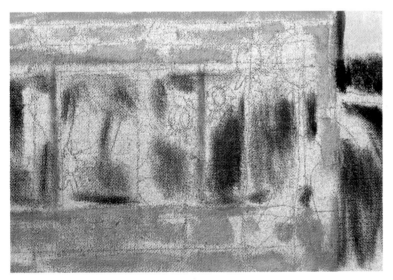

Fig 8.23 With a no. 4 bristle brush, I scrubbed in the mixture for the shed. The coarse-grain canvas has the effect of absorbing the paint, which meant that I could apply the colour of the sunflowers on top, without fear of too much contamination from the underlying colour. This would not have been possible on a smooth surface. Applying the background colour first meant I could set the tonal balance of the painting ahead of painting the flower heads.

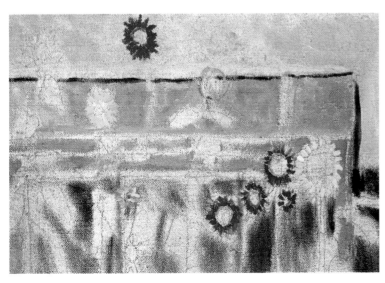

Fig 8.24 I loaded a no. 6 sable with white, cadmium yellow with a touch of lemon yellow. I plastered it onto the yellow sunflowers. In similar fashion, I loaded another no. 3 sable with cadmium red, permanent rose and white. Again, I applied it onto the red flower heads and the colours immediately stood out against the subdued background.

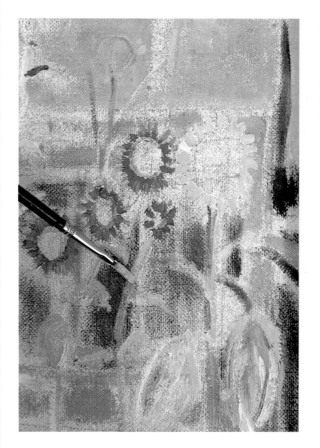

Fig 8.25 With a clean no. 3 sable, I mixed lemon yellow, pthalo blue and loaded it with white. I then applied the mixture onto the pale areas of foliage – you can see how the colours used on the sunflowers are hardly contaminated by the background colour at all and the thick paint sits on top of the canvas, as opposed to being absorbed into the weave.

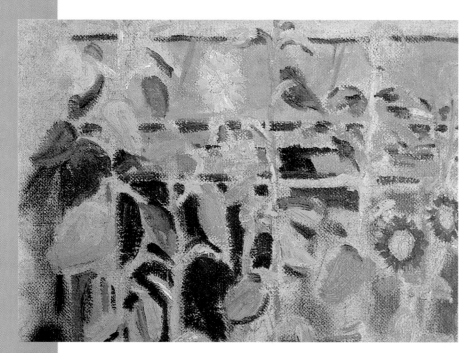

Fig 8.26 Now that the pale and bright colours have been applied, I was able to reinforce the dark areas of the background. With a no. 4 sable, I mixed lemon yellow, viridian, pthalo blue and a little permanent rose and applied this mixture onto the dark areas of foliage. With the same brush, I introduced burnt umber and ultramarine, and applied it onto the shed wall and the window.

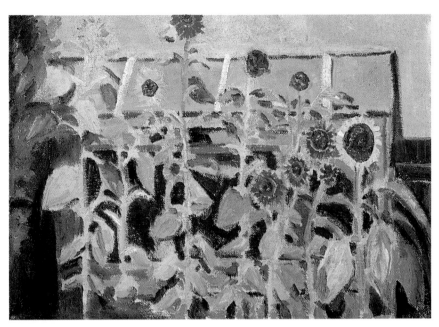

Fig 8.27 Reinforcing the dark areas of the painting in this way brought out the sunlit flower heads even more. In fact, they almost leap out of the painting, just as they would during a bright and crisp autumn morning. I introduced more greens onto the foliage, blending a little in places to give them more form, and used burnt umber on the seeded hubs at the centre of the sunflower heads.

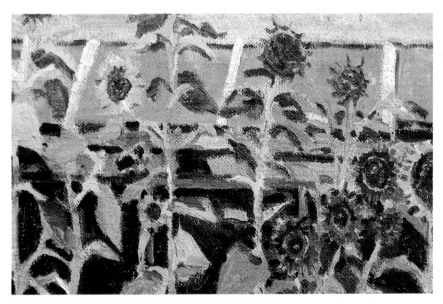

Fig 8.28 With the 'yellow' brush I had used earlier, I introduced form to the sunflower heads. I mixed a little burnt sienna and permanent rose, and dabbed it onto the shaded contours of the petals, so that the sunflower heads appeared to be lit from the side. Thicker paint was used towards the end of the painting session.

Don't be afraid of using colours neat from the tube. Sunflowers provide a rare opportunity to do so and I decided to make the most of it.

115

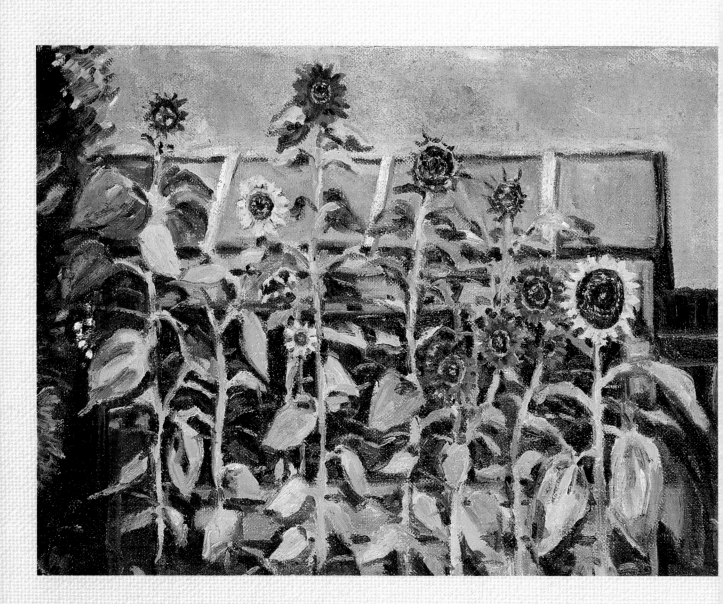

Sunflowers, 30.5 × 40.5cm (12 × 16in) coarse-grained stretched canvas

Chapter 9

Figures out of doors

Much can be revealed about the way we live and the way we relate to one another when surrounded with the familiar. We are at our most natural within our own environment and because of this the figure becomes more interesting in that situation. But the study of the figure is very much like the study of a flower head. There are no straight lines, angles or vanishing points to adhere to - only the skill of observation. It helps to throw away the label of what it is you are drawing and to simplify the object into basic shapes and key lines.

Copying from a photograph is a good place to start. Choose a simple composition with no more than two figures. Place a sheet of tracing paper over it and draw the outlines, leaving out the detail. When you have done this, copy the tracing freehand onto some sketching paper. Don't worry if you do not get it right. Use the eraser as many times as you wish.

This is no test. Practise this exercise as many times as you want with other photographs and your skills of observation will improve.

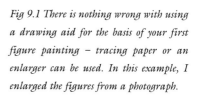

Tip

If you feel something is wrong with your drawing but you cannot define the problem, reverse the sheet and hold it up to the light or view it through a mirror. Alternatively, turn it upside down. Viewing the drawing from an unfamiliar angle will clarify the mistakes.

A straight copy from a photograph in two sessions

Session one

Choose a simple composition, comprising no more than two figures. The most natural photograph is often one that has been taken spontaneously. A dozen or so photographs often precede it. I chose this photograph for that very reason.

Fig 9.1 There is nothing wrong with using a drawing aid for the basis of your first figure painting – tracing paper or an enlarger can be used. In this example, I enlarged the figures from a photograph.

Fig 9.2 Once I had enlarged the photograph, I embarked on the pale flesh tones. I mixed burnt sienna with white and dabbed it onto the sunlit faces with a 00 sable. It is always a good idea to begin with the most intricate areas at an early stage in the painting session, whilst you are still feeling fresh.

Fig 9.3 I introduced burnt umber, ultramarine and burnt sienna into a little white and applied it onto the shaded parts of the faces. Be careful when painting shaded areas of flesh, as even the smallest addition of a colour can appear too heavy. Be prepared to wipe off the surplus pigment and to make the mixture more subtle. As you can see, the flesh tones are applied at the same time.

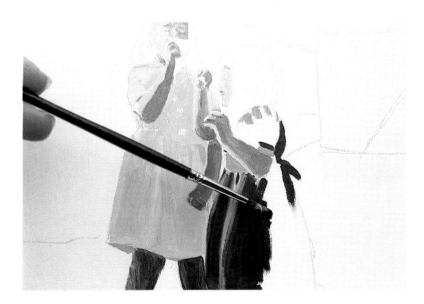

Fig 9.4 Next, the dresses. I mixed pthalo blue, white and burnt sienna and applied it in various quantities to the blue dress. The darker dress is composed of permanent rose, ultramarine and burnt umber. I used a no. 3 sable throughout. Don't worry too much about detail at this point, or the correctness of the tones: the second glaze will give ample opportunity to modify these points.

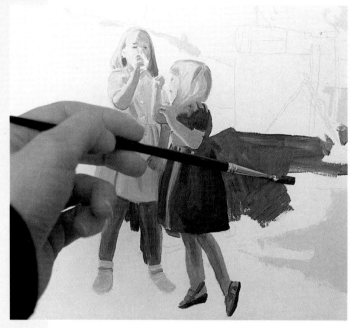

Fig 9.5 Next, I blocked in the greens, using a no. 6 sable. I mixed the dark greens first, from permanent rose, burnt sienna and viridian. The sunlit areas consisted of lemon yellow and white. With larger areas, I used a no. 4 bristle and then smoothed over the brush marks with a clean sable.

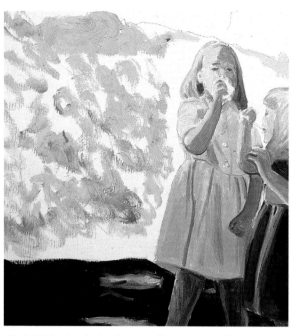

Fig 9.6 I dry-brushed cadmium yellow onto the hedge on the left, and then worked around it with pthalo blue and viridian. This is consistent with the logic of applying the pale colours before the darks on any complex area. I blended the edges together, using a clean sable.

Once I had covered the entire board, I put the painting away for approximately two weeks. The photograph was kept nearby.

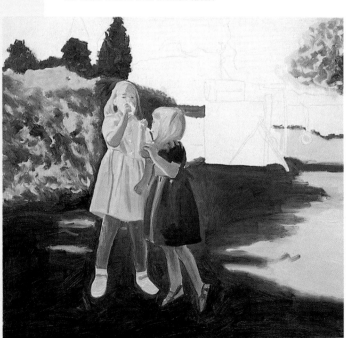

Fig 9.7 I continued to block in the background, finishing with the playhouse and the sky. Before ending the first session, I gently brushed away any ridges with a clean sable. This eradicated any unwanted textures that might interfere with the overlying paint.

Session two

The painting, by now, should be touch-dry, so it is time to begin the second and final stage of the painting. You will find, on applying the second layer, that the first will emphasize the colours and tones of the second. It is like the cement that binds the painting together.

Fig 9.9 *I worked over the figures in the same order as shown in the first session. You will see that the first layer of oil paint supports the second – depth is added to the colours, and detail is sharpened up. The background is completed in the same way.*

Fig 9.8 *With the second coat, I introduced a dab of linseed oil. I wanted the paint to be as opaque as possible, but at the same time, to give the upper layer of paint flexibility. This conforms to the 'fat over lean' rule (explained in Chapter 1, page 8). Again, I began with the flesh tones. I mixed white with a dab of burnt sienna and then smoothed it over the first layer, using a 00 sable.*

Fig 9.10 *The final touches comprise the soap bubbles. A thin layer of white and ultramarine is applied using a 00 sable and highlights added by dabbing a little white at chosen places. I added a few more bubbles than were shown on the photograph, to add more interest.*

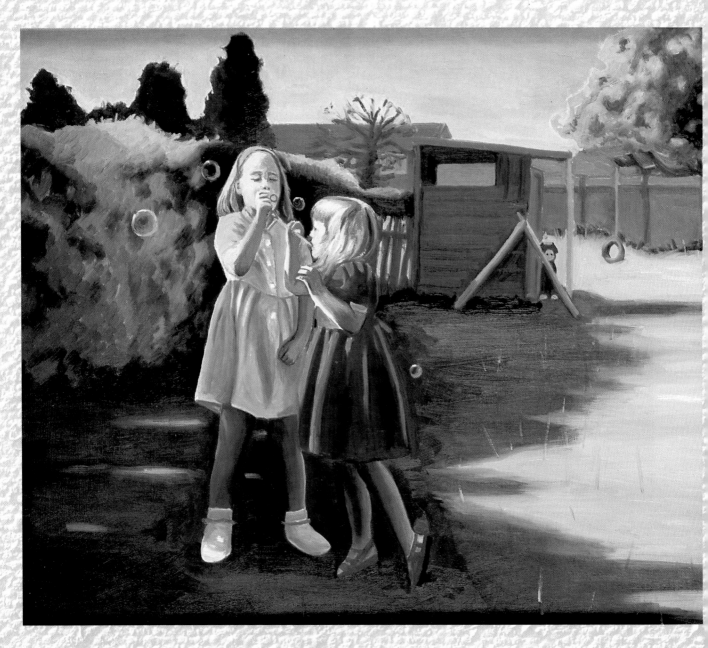

Soap Bubbles, *25.5 × 30.5cm (10 × 12in)*

Composing a picture

An interesting composition can be formed by using more than one photograph and piecing them together. There are hidden treasures within every photographic collection. Maybe the makings of a gem if it weren't for a disappointing background or an empty space. These photographs can be ideal material for a painting.

When flipping through your photographs, put to one side anything that catches your eye – not necessarily the perfect photograph, but one that has captured something, such as a person off guard, a posture, an expression or an action. Anything that interests you.

Ensure the quality of the picture is good and that it shows the figure in reasonable detail. Avoid any photograph where the figure is too small or out of focus, as you will need to see the detail when working from the photograph.

Now, sort the photographs into piles. This is necessary because some photographs cannot be used together. For instance, a figure lit from the left cannot exist beside a figure lit from the right. Consider getting a reversed print from the negative, if you really want to use a particular photograph. In the same way, figures look more natural together if their photographs were taken from similar viewpoints and distances. Be wary of sizes. In all my group paintings, the figures exist on the same plane, so the sizes can easily be worked out.

Fig 9.12 In the following demonstration, Cooling Off, I used a combination of photographs that were taken on the same afternoon during a water game. Notice how the shadows are consistent, the figures are viewed from a similar angle and they all knit together.

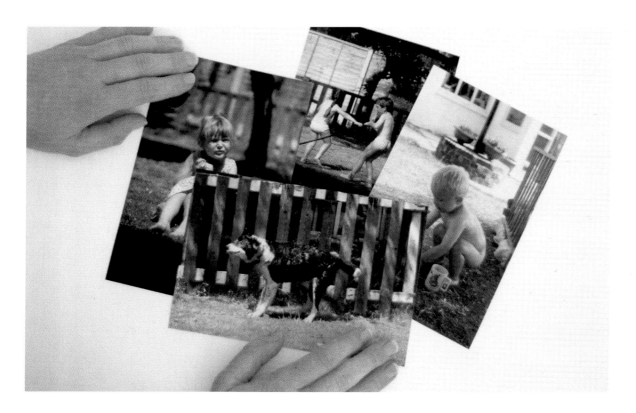

Take your time when working out your group painting. Once it has been drawn out, put it away for a while. Anything which is not quite right will soon show up when viewed with fresh eyes. This saves on frustration later.

Flesh Tones

Fig 9.13 Firstly, I laid down an acrylic wash of pthalo blue and a dab of permanent rose over the drawing. Once dry, I started on the figures. I mixed white with a dab of burnt sienna, to give a creamy, warm colour, ideal for sunlit flesh tones, and applied this to the areas concerned.

Fig 9.14 Next, I mixed the colours for the shaded flesh tones, using a separate brush. I mixed white, burnt sienna, a little cadmium red and a dab of ultramarine, to make a violet colour that is often reflected back from a blue sky. I applied the same colour to the highlights in the dog's fur. With the same brush, I added a little more burnt umber and dabbed this heavier colour onto the darkest areas of flesh.

Fig 9.15 With a clean brush, I mixed permanent rose, ultramarine and burnt umber and then applied it to the dark areas of fur. I then used the pale brush to soften the edges of the highlights. The fur now appeared to be gleaming, as though sprayed with water.

Fig 9.16 Before finishing the first glaze on the figures, I took a soft, clean rag and formed it into a pad. I then dabbed the flesh areas gently, working from light to dark. Shift the rag to a clean area each time you dab a different part of the painting. Repeating this process will eventually achieve an almost air-brushed quality to the paint.

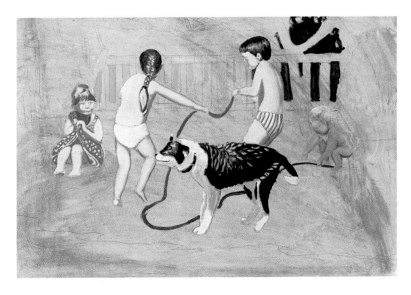

Fig 9.17 Once I had completed the first session on the figures, I blocked in the background. This will ultimately reveal any tonal imbalances within the painting. Don't worry if anything looks washed-out or too dark. Working in layers provides the opportunity to put this right. Once I had finished for the day, I put the painting away for two weeks.

Achieving a high finish

In the same way as shown in the previous demonstration, *Soap Bubbles*, the first layer of paint will work along the second layer. However, in this demonstration, I wanted to work towards a more polished finish. Once the painting was dry, I worked over the flesh tones in the same way as before. Again, remember to introduce a dab of linseed oil into your mixes when working in successive layers.

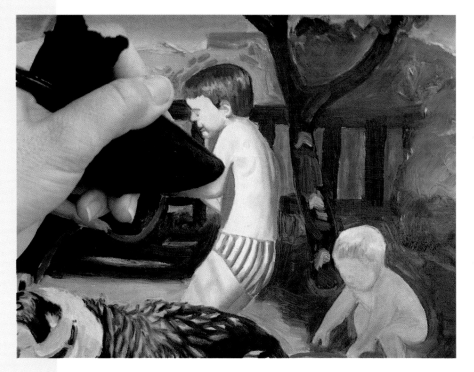

Fig 9.18 Some areas of the figures were looking washed-out. I adjusted the tones by mixing deeper colours, which were more in keeping with the background. Detail in the figures was also introduced, along with more definition. Now that the figures were more refined than before, I needed a more precise way of smoothing the flesh tones, so I cushioned the butt-end of a wide brush within a folded, soft, clean rag, to provide a blunt end. Any blunt-ended instrument would have been suitable. Again, I dabbed gently at the flesh areas, working from light to dark.

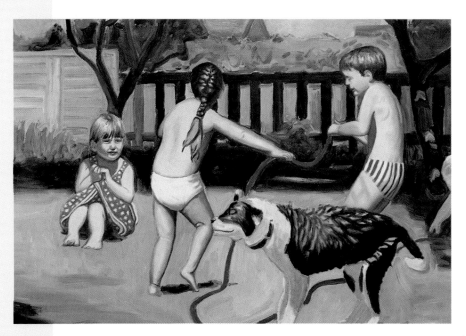

Fig 9.19 The other figures were worked over in the same way. Remember to use a clean part of the rag each time you work on a different area. Keep going over it until a smooth gradation in tone is achieved. Attaining a smooth and detailed finish on each figure can be time consuming, but is ultimately rewarding. It is a good idea to complete each figure on separate days.

Fig 9.20 The final figure to the right consisted of a different palette from the other figures, for he is the only one in complete shade. Cooler colours were required, although some were still pale. Dabs of burnt umber, ultramarine and pthalo blue were introduced into lots of white. A little burnt sienna was necessary in certain areas. The flesh colour was then dabbed with a clean, soft rag in the same way as the other figures.

Fig 9.21 The background will appear unrefined compared to the highly detailed and smooth figures. With a soft brush, I worked over the lawn, the trees and sky, softening and sharpening up the edges. The background often takes less time than the focal points within the painting. The final touch was the water spray, as can be seen in the finished painting. I mixed a little ultramarine with lots of white, and then dabbed it around the dog and the top of the hose-pipe, using a 00 sable.

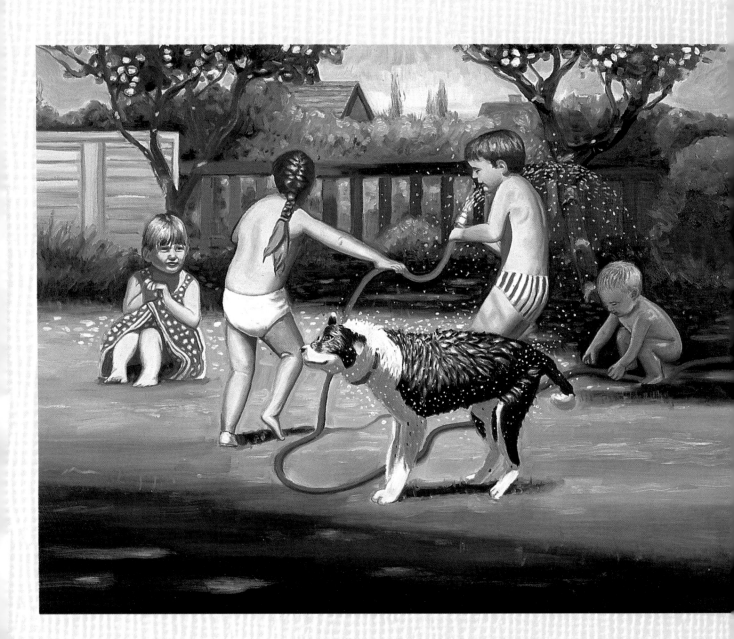

Cooling Off, *30.5 × 40.5cm (12 × 16in)*

Fig 9.23 The flesh wheel

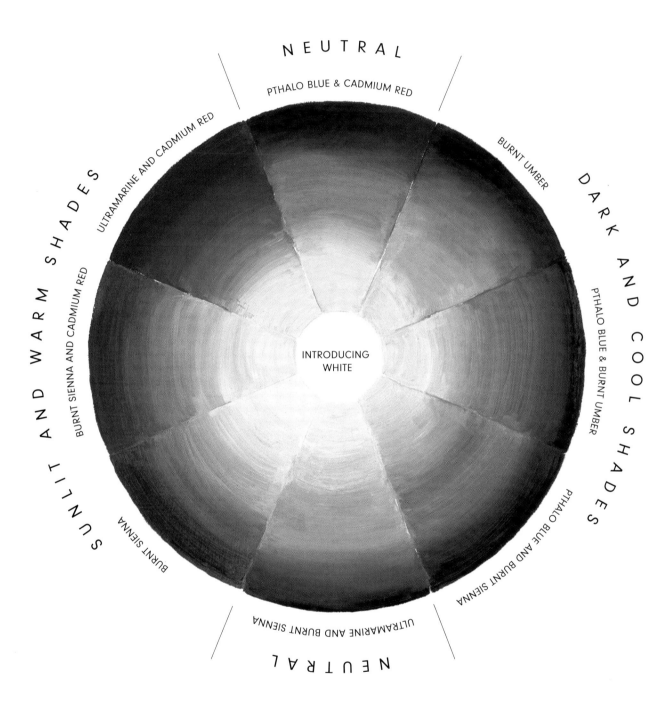

NEUTRAL

PTHALO BLUE & CADMIUM RED

ULTRAMARINE AND CADMIUM RED

BURNT UMBER

DARK AND COOL SHADES

SUNLIT AND WARM SHADES

BURNT SIENNA AND CADMIUM RED

PTHALO BLUE & BURNT UMBER

INTRODUCING WHITE

BURNT SIENNA

PTHALO BLUE AND BURNT SIENNA

ULTRAMARINE AND BURNT SIENNA

NEUTRAL

Flesh tones often consist of the most unlikely colours – violets, blues, even green. The flesh wheel, however, simplifies and summarizes the colours I used in *Cooling Off*. You will find the mixes which were used in sunlit flesh tones, warm flesh tones, cool flesh tones and shaded flesh tones.

Figures from life

For some, painting figures from life can seem the most daunting task of all. However, there are ways to avoid problems and unnecessary work.

Firstly, it is a good idea to work out the composition and the surrounding area before sketching the figures themselves. This prevents the subject matter from sitting still for longer periods than necessary. The subject need not even be present.

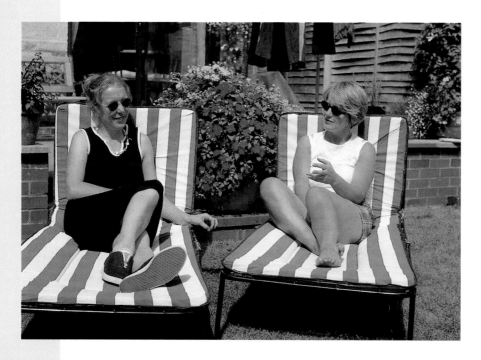

Fig 9.24 This was the method used with these sunbathers. The sun loungers, the background and the rest of the composition were mapped in before the figures were sketched. I knew the figures would be placed comfortably within the picture before I had even begun sketching them. When the time came to sketch the figures, much of the hard work had been done already.

Fig 9.25 I chose fine-grain stretched canvas, as I wanted the paint to move freely over the surface. This was necessary to get the paint down quickly. However, I envisaged that a textured surface, albeit fine, would complement the subject matter. A thin acrylic wash of burnt sienna was laid down on the canvas. The composition was then sketched on top, using a soft pencil.

Fig 9.26 I embarked on the flesh tones early on – the figures had now settled down and I needed them to sit still. With a no. 1 sable, I mixed burnt sienna, white and a little linseed oil. I applied this mixture onto the pale tones. I then mixed extra white onto the brush and added the highlights. More linseed oil was introduced when the paint became sluggish.

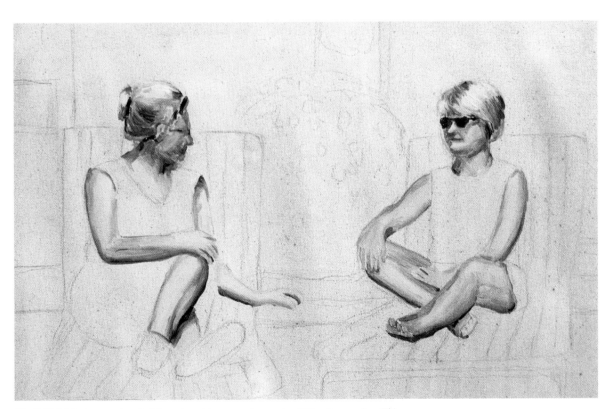

Fig 9.27 With the same brush, I introduced burnt umber and a little ultramarine. This was dabbed onto the shaded areas of skin. This colour at first seemed too heavy, but I knew that, once the background was laid down, the tonal balance of the figures would key in to the rest of the painting.

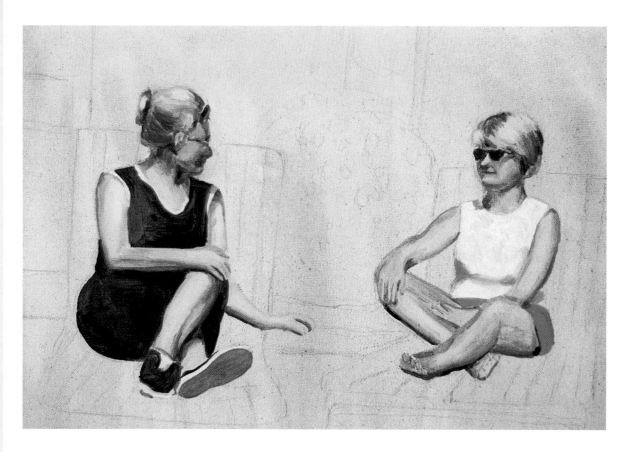

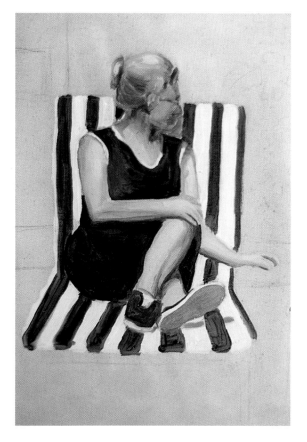

Fig 9.28 With a no. 3 sable, I applied neat white onto the piping of the dress and the soles of the shoes. This pale colour was similarly used for the other figure. A little pthalo blue was introduced to the folds in the material. I then mixed ultramarine, permanent rose and burnt umber. This was used for the dress.

Fig 9.29 The figures were now free to get up and down as they wished. With a clean no. 3 sable, I applied neat white onto the stripes of the chairs and, with a different no. 3, I applied viridian green and a little burnt sienna. Notice how even the highlights of the flesh are much darker than the white on the sun lounger. Skin tones are often much deeper than white.

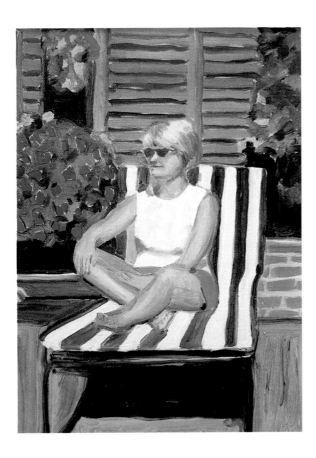

Fig 9.30 The rest of the painting was now simply a matter of blocking in. I ensured the background remained darker in tone than the figures – even the sun-drenched grass. This ensured the figures would stand out within the painting.

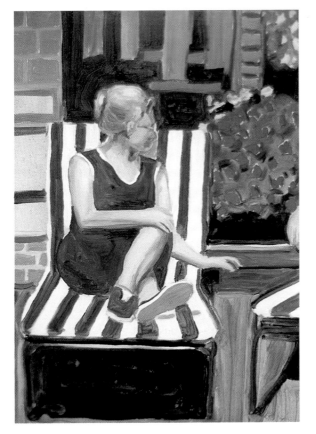

Fig 9.31 Now that the canvas was covered, I could touch up any rough areas. With a clean no. 3 sable, I blended the flesh tones a little in order to soften any sharp edges. The groundwork, however, had already been done. Sketching the figures at an early stage in the painting session is a practical way of capturing the figures from life while you and the subject matter are feeling fresh. Inanimate objects will wait.

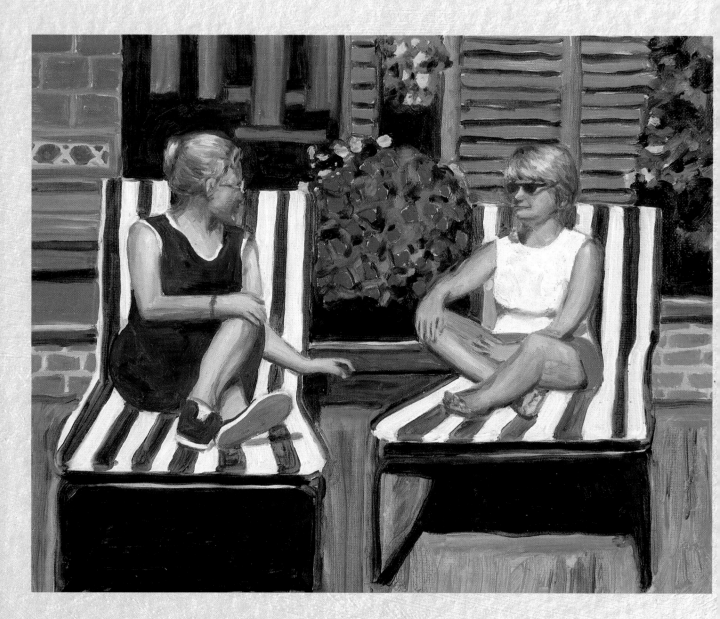

Sunbathers, 30.5 × 40.5cm (12 × 16in) fine-grain stretched canvas

Chapter 10

Shelter from the elements

Throughout the year, the garden reveals alternate views. A snow-covered garden can appear to be a different garden from the same one in the spring. Each version makes up a part of the complete picture.

Most of this book has examined the garden when conditions are comfortable for sitting outside. But being able to make a study of the garden during inclement weather can be very rewarding – and easily done from the comfort of your home. This is because one need not sit in the garden in order to capture its many moods. The conservatory, the kitchen or an upstairs window can create new possibilities for garden studies, particularly when it is cold outside.

A coat of many colours

Fig 10.1 A rather ordinary scene from the bottom of the garden can be transformed by a layer of snow. Reddish-purple winter sunlight added a touch of magic to this particular scene. As a result, the snow was anything but white. It contained ultramarine, pthalo blue, burnt sienna, permanent rose, cadmium red, and cadmium yellow. However, making an effective snow study is all about subtle variations in tone. Snow can be slightly creamy or slightly bluish or slightly rosy. No matter how small the variations are, the eye perceives them clearly. This is the key to capturing snow in the garden. I set myself up just after lunch within a heated shed. This meant I had around two hours of sunlight.

Fig 10.2 Firstly, I pencilled in the scene on oil-sketching paper. Oil-sketching paper is a useful alternative to canvas or board if storage space is limited. A quick succession of oil sketches can be completed in the same way as using a pad. The paper had been clipped onto a piece of backing-board, to provide more support than the sketch pad. It also prevented the sketch pad from becoming soiled.

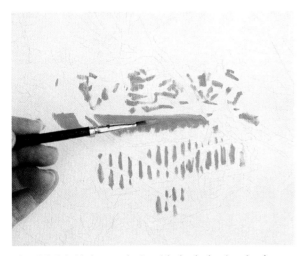

Fig 10.3 I decided not to begin with the dark mixes for the trees and the fence, as this could contaminate the snow mixes, which had to be pure. The first stage of the painting, therefore, had to be the palest areas of snow. I mixed a dab of pthalo blue and permanent rose into lots of white. With a no. 3 sable, I applied the mixture onto the field in the background.

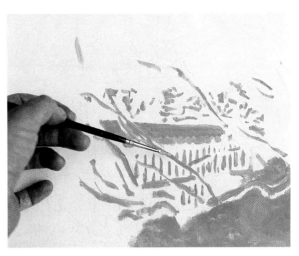

Fig 10.4 I darkened the mixture slightly with a little more permanent rose and a dab of ultramarine. Burnt sienna was introduced in places. I applied the mixture onto the foreground and the snow on the lower branches. These areas were overshadowed by the trees above them, giving them a grey-mauve quality.

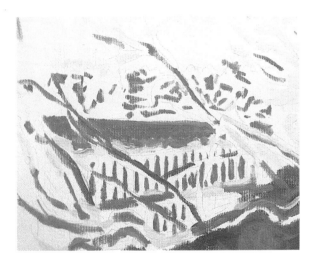

Fig 10.5 I moved onto the upper areas of the painting which, on the whole, were paler in tone. I used a clean no. 1 sable and mixed white with a dab of burnt sienna. The mixture was applied onto the upper branches holding the snow. This provided a nice contrast against the darker mix of snow on the lower branches.

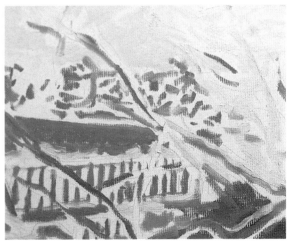

Fig 10.6 With a no. 4 bristle, I mixed a little pthalo blue with lots of white and then daubed it onto the sky. I allowed the texture of the brushwork to remain, as it added expression to the oil sketch and I was careful not to conceal the pencil marks beneath. However, darks can always be applied over pales, so care was not required around the smaller branches, which could be worked again. The painting will probably make little sense until the dark areas of paint have been applied.

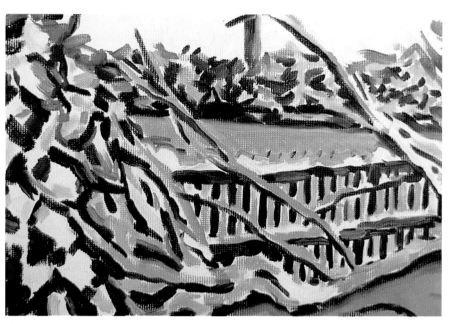

Fig 10.7 With a no. 3 sable, I mixed burnt umber, ultramarine and permanent rose. I pasted the mixture onto the fence, the branches and the background of trees. All of a sudden, the painting pulled together and the snow appeared more realistic.

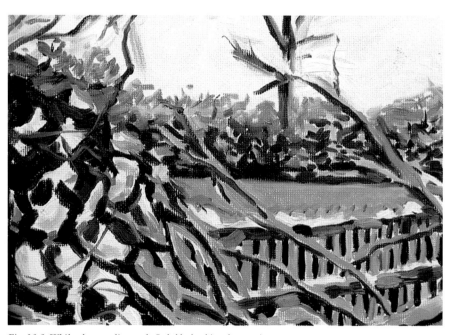

Fig 10.8 While the sun lingered, I dabbed white, burnt sienna, permanent rose and a little cadmium yellow onto the sunlit snow and around the top of the fence. The rest of the snow suddenly appeared chilly by comparison.

As you can see, the palette required for the garden in winter could hardly be more different from the colours found in spring.

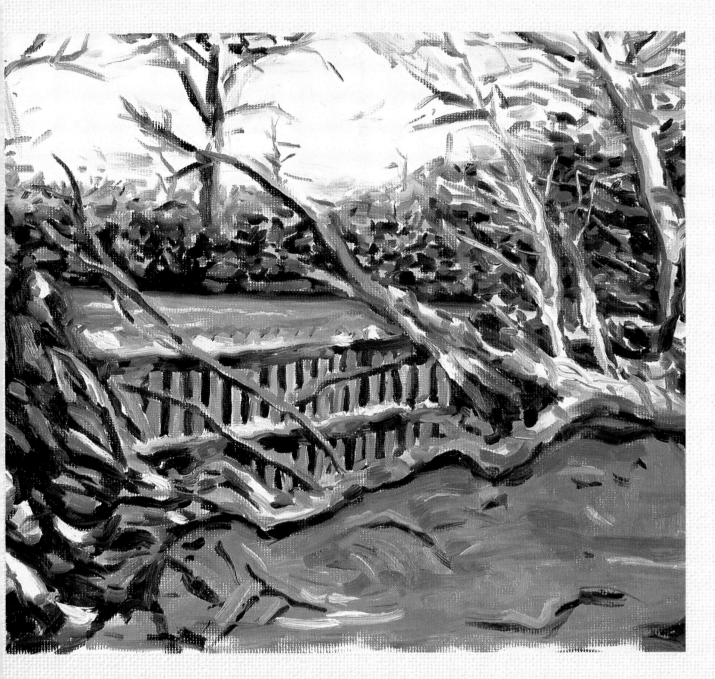

Snow Scene, *25.5 × 30.5cm (10 × 12in) oil-sketching paper*

The upper part of the garden

Fig 10.10 and Fig 10.11 As well as the elements, the sky plays a fundamental part in the mood of the garden. The colour of the clouds can reflect onto the lawn, path or the rooftops. My favoured format for a sky sketch is to use a low horizon. This can easily be achieved from the garden.

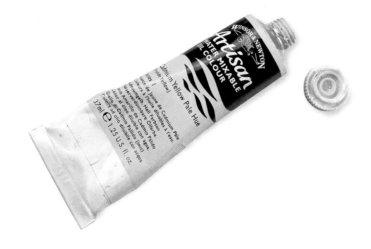

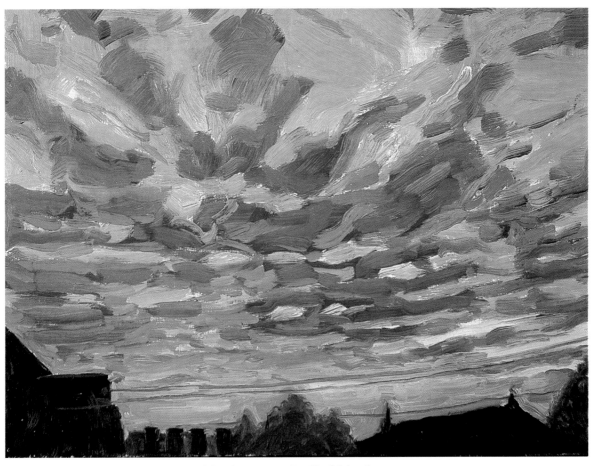

A good place to start is to select an interesting skyline from your garden. Sketch it low down on your support. When an interesting sky comes along, you can begin on the sky without having to sketch the rooftops or trees first. This is what I did with these two sunsets completed in late summer. Bear in mind that there will be a seasonal shift in the position of the sun in relation to your portion of sky.

Tip

On your first attempt at a sky sketch, work on slow-moving clouds. Use no smaller than a no. 3 brush. This means that the board can be covered quickly. Apply the palest colours first and direct the brushstrokes into the movement of the clouds. Be general about the feel of the sky. There is no point in applying detail. The clouds will not wait.

The sky in perspective

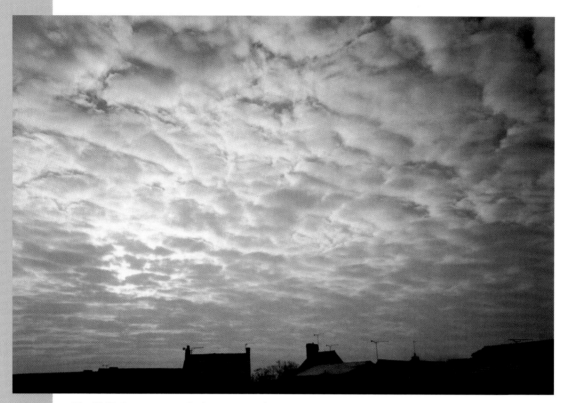

Fig 10.12 In autumn and winter, one need not get up early to capture a beautiful sunrise. I began painting this autumn sky around mid-morning. The sky had a flat, fish-scale quality, which usually means the clouds are moving slowly. The rear bedroom window offered an ideal vantage point.

Fig 10.13 The sketch of the horizon had been completed on oil-sketching paper a few days earlier. I could anticipate where the sun would rise and simply wait for the ideal sky. To add further interest, the rooftops existed at different levels. These, in turn were broken up by the hedges and trees at the bottom of the garden.

Fig 10.14 I began with the brightest areas of sky. Painting the dark buildings first would risk contaminating the mixes near the horizon. With a no. 3 sable, I pasted on white and varying tints of burnt sienna and permanent rose. I dabbed the mixture onto the bright areas between the clouds. Notice the perspective of the sky. The clouds appear flat and more regular as the sky recedes.

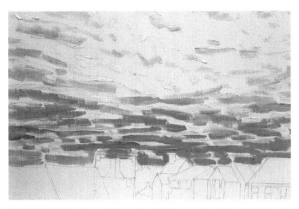

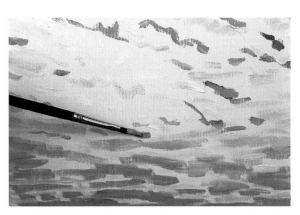

Fig 10.15 Next, I worked on the darker patches of cloud. Only the slightest dab of ultramarine was necessary. I then introduced a small dab of burnt sienna for the darkest areas. Clouds, like flesh tones and snow, consist of the most subtle variations in colour and tone. Introduce any pigment gradually. This will prevent the mixtures ending up too heavy.

Fig 10.16 With a clean no. 3 sable, I mixed white and pthalo blue. The colour was applied to the sky between the clouds. More white was introduced near the horizon, where the sky appeared at its palest. The gaps appear darker near the highest point. I introduced more pthalo blue and a little burnt sienna around these areas.

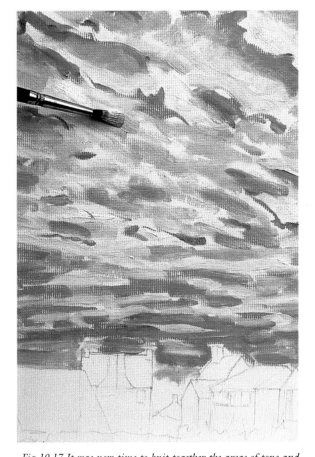

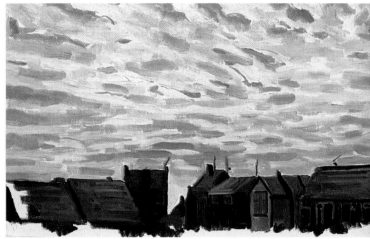

Fig 10.18 The sky is almost always much lighter in tone than the ground. Since much detail can be seen in the clouds, the rooftops had to appear almost black in order to achieve tonal parity. I mixed ultramarine, burnt umber and permanent rose. The mixture was applied in varying degrees to the buildings. Even the white windows were made very dark by mixing pthalo blue and burnt sienna into the white.

Fig 10.17 It was now time to knit together the areas of tone and colour. With a clean, soft sable, I blended the edges together. The view from the bedroom window had altered too much to be of any use for reference. Still, I had all the reference I needed. All that was required was the final blending and knitting together of the paint.

Rooftops, 25.5 × 30.5cm (10 × 12in) Oil-sketching paper

Bringing the garden indoors

As can be seen from *Snow Scene*, winter does not mean that the garden cannot be painted. Furthermore, the sun filtering through the window can provide an ideal setting for the garden in winter. It's warm and the benefits of the sunlight can still be reaped.

I wanted this depiction of flowers to have a different slant. I used the curtain of the bedroom window to split the arrangement into two. The sunlit side reveals the flowers and the berries in detail. Notice how the arrangement is illuminated up against the dark background. The other side behind the curtain, however, communicates in a totally different way. Only the silhouette is revealed, and the shape of the arrangement is darker than the background.

Fig 10.20 I took cuttings of St John's Wort and bright red berries from the garden and arranged them in a vase and a teapot.

Fig 10.21 I sketched the composition briskly. I then overlaid the drawing with a dark acrylic mix consisting of pthalo blue and permanent rose to ensure the lines would show through the subsequent glaze.

Wet-into-wet

Wet-into-wet simply means working onto wet paint. Throughout this book, the oil paint has been applied onto a dry acrylic wash. Working wet-into-wet is different. The surface is not dry, so the application of paint flows in a less controlled manner. Interesting effects can be achieved in this way.

Fig 10.22 When practising wet-into-wet with oils, never use acrylics, for this is a water-based medium. In this demonstration, I used an underwash of oil paint suspended in oil-based mediums. Any colour can be used for a wet glaze. In this case I decided to use a warm colour. Firstly, I squeezed out a cherry-sized dollop of burnt sienna and permanent rose into a small container. Four to five drops each of low odour artists' solvent and linseed oil were then added. I mixed this together, making small adjustments until the solution was a little runny.

Fig 10.23 I applied the mixture briskly onto the board, using a 2.5cm (1in) brush. When applying a wet glaze, tilt the board by at least 45° so that the fluid paint will not dribble. This solution will remain wet for at least four hours, which should be ample time for the painting session.

Fig 10.24 Applying paint onto a wet surface means having to use more paint than usual, or the colour will mix into the wet glaze. For this reason, I loaded a no. 4 bristle with white and daubed it on. Being too sparing with the pigments might result in the painting looking muddy.

Fig 10.25 The first encounter with wet-into-wet can be a daunting experience. The secret is to take charge of the brush and the paint and yet also to give it the freedom to do what it wants. Allow the paint to glide over the glaze. Let the paint pick up some of the underlying tint. This will give the painting a fluid and expressive look.

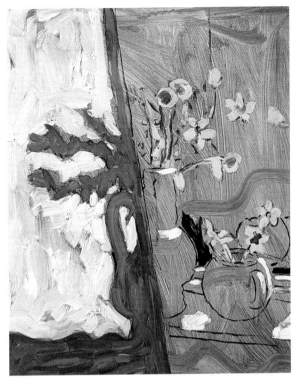

Fig 10.26 I worked on the silhouette next. I mixed ultramarine with permanent rose and daubed it on with the same no. 4 bristle. I allowed the wet glaze to show between the areas of white and mauve, to inject warmth into the painting.

Fig 10.27 With a clean no. 3 sable, I mixed cadmium yellow, lemon yellow and loaded it with white, then applied it to the flower heads. I made the colour as bright as possible, to emulate the transparency of the petals. Variations in tone were introduced with burnt sienna, to give the flowers form.

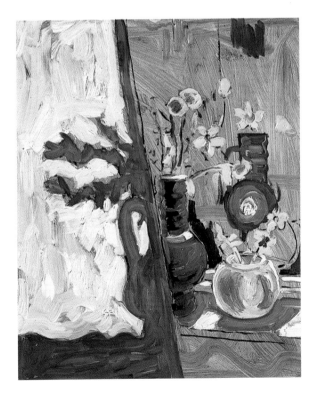

Fig 10.28 Deeper colours were used for the vase and the teapot. The vase consisted of pthalo blue and permanent rose, darkened with a little burnt umber. The teapot, although white, appeared dark. I used white, burnt sienna and a dab of ultramarine. With a no. 1 sable, I dabbed neat cadmium red onto the berries and then white for the highlights. Before finishing the painting, I blocked in the background. By applying this dark colour, the flower heads suddenly appear illuminated. This gave focus to the painting.

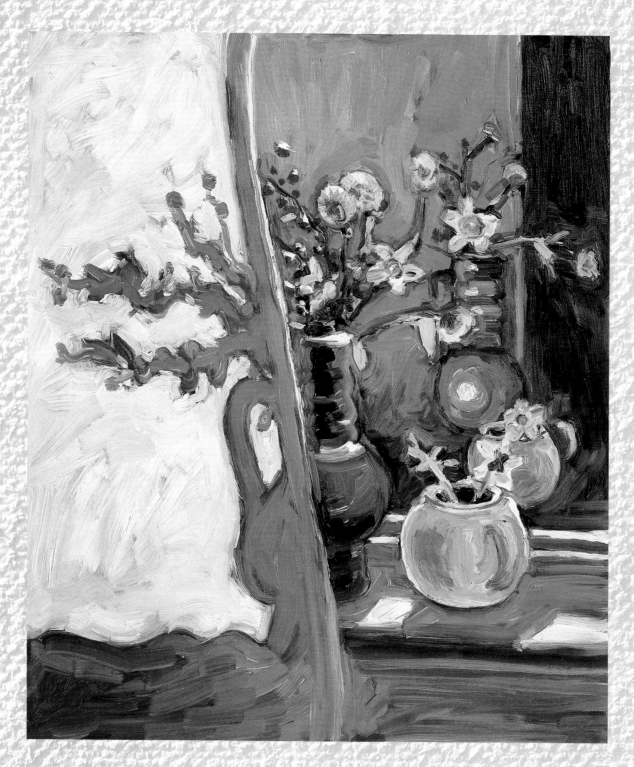

St John's Wort and Winter Berries, 25.5 × 30.5cm (10 × 12in)

Chapter 11

Care of the paintings

Oils are perhaps the most robust and durable of all the art mediums. Little attention, therefore, is required. However, any problems that are associated with oil paintings often go back to the improper application of oils and their related materials.

As with anything, never use a substitute product for the one that is designed for oil painting. For instance, avoid using household emulsions or cheap primers to prepare the painting support. Some of these may not provide a sufficient barrier against the absorbent properties of the canvas or board. The result of this is that the still-absorbent support will suck the oil vehicle from the paint and cracking may result.

Do not use mediums and solvents designed for household use in place of those specifically produced for oil painting. They can affect the permanence of the pigments. Never combine mediums with varying drying rates, such as stand oil and alkyd mediums. This will cause stresses in the painting and inevitable cracking. When working in layers, introduce a little more oil medium into your paint, as in the 'fat over lean' rule (see Chapter 1, page 8). This will provide flexibility to the upper layers.

Proper preparation and use of oils and other art materials will prevent numerous problems from cropping up in the future. Read the manufacturers' instructions if you are unsure. Above all, avoid short cuts.

Once dry, oil paintings can be stored anywhere, so long as the environment is dry, dust free and not subject to extremes of temperature. Keeping them for lengthy periods in the dark may cause a slight yellowing of certain pigments. Permit your paintings some daylight, although not direct sunlight.

> ### Tip
>
> Dull patches may appear on an oil painting when dry. This is called 'sinking' and is caused by the oil in the paint being depleted by an absorbent layer beneath, or by using too much solvent in your mixes. Lightly apply a little linseed oil onto the spot. Allow to dry and repeat if the area becomes dull again. This will nourish the paint. This procedure is called 'oiling out'.

Varnishing

Varnishing provides a protective layer against any damaging agents in the air, such as dust, dirt and damp. Most varnishes, therefore, are designed to be removable. This is done every ten to twenty years or so. A fresh coat can then be applied.

Varnishes also have the effect of restoring the oil painting's original 'wet' look. This is why varnishes are often considered to be the finishing touch to a painting.

Fig 11.1 A selection of available varnishes

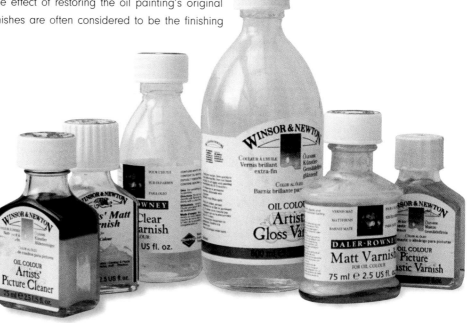

Fig 11.2 (a) Firstly, pour a finger's width of varnish into a jar that is wide enough to take the varnishing brush. Keep the lid on as much as possible. The brush used should be soft, clean and around 2.5–5cm (1–2in) wide. Reserve it only for varnishing. Dip the end into the varnish. Try not to overload the brush.

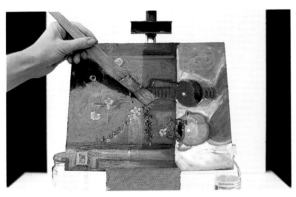

Fig 11.2 (b) Apply the varnish in an even layer, brushing in all directions. Keep the brush moving, as the varnish will become more tacky in about half an hour.

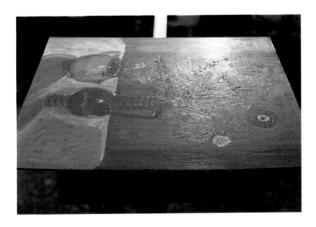

Many different varnishes exist. The older types of varnish are made from natural resins. Damar and mastic varnish are two such examples. Natural varnishes are preferred by some artists for their unique finish. In recent years, however, varnishes have been developed from synthetic resins and these offer some advantages over their natural counterparts. They are completely colourless and are less likely to darken with age or to crack. In ideal conditions, a synthetic varnish should not need replacing for 20 years or more.

Different varnishes offer different finishes. These can be narrowed down to matt and gloss. Satin finishes are available for an effect somewhere in between. Varnishes are usually available in jars and applied by brush. Spraying varnish from an aerosol is an alternative if brush marks are to be avoided on smooth and detailed work.

Ensure the painting is thoroughly dry before applying the varnish. This takes at least six months after completion. In the case of alkyd oil, allow three months. Thick impasto requires an additional month or two. 'Retouching varnish' is a temporary measure if the paint is not dry throughout. This can be useful for exhibiting work at short notice.

Before varnishing your work, give it a light dusting with a soft brush, preferably outside. The room in which you varnish must be well ventilated and dust-free. Varnishes can emit powerful odours, so allow the work to dry behind a closed door or in the shed.

Varnishes can easily be removed with artists' solvent or a special varnish remover. Dab a little onto a clean rag and wipe off gently. Repeat until all the varnish is removed. Always use solvents in a well-ventilated room.

Fig 11.2 (c) Check for areas missed by holding the painting up to eye level and against a window, or other light source. Tilt the painting in all directions and the dry spots will show up where the light does not reflect back. Touch up where necessary. Allow the painting to dry, lying flat for 24 hours. Clean the brush thoroughly in artists' solvents and then lather in soap or washing up liquid. One coat will usually suffice, although two may be necessary. Ensure the varnish is thoroughly dry before applying the second coat.

Presenting your work

Once the painting has been varnished, you may begin to consider its presentation. The presentation of an oil painting can make a world of difference. It can make a painting look imposing or intimate, or bring out certain qualities. It can also be its downfall. This is why presentation is important.

The traditional method of presenting an oil painting is to fix it into a frame. Frames can be purchased ready-made in standard sizes. These conform to the sizes I have recommended for the supports in Chapter 1 (see page 15). Frames, therefore, can be purchased in the high street and your painting will slot straight inside. Of course, you can always have your frame tailor-made, but bear in mind that this can be costly.

Fig 11.3 A heavy dark frame can make a small oil sketch appear substantial.

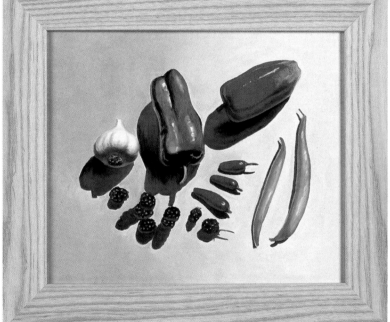

Fig 11.4 The natural grain of pale wood complements this highly detailed study of fruit and vegetables.

I believe that oil paintings need room to breathe, so I would recommend a wide surround – at least 5cm (2in) on each side. A chunky frame made from natural wood can emphasize an impasto sketch of the garden. Some artists will even batter a new frame to give it a rustic and aged look. On occasion, I have found the genuine article from house clearance sales or a car boot. An unusual frame can be a bonus.

It is a good idea to invest in a collection of frames for future creations so that you don't have to make do if a good frame shop closes, or a favourite design becomes obsolete.

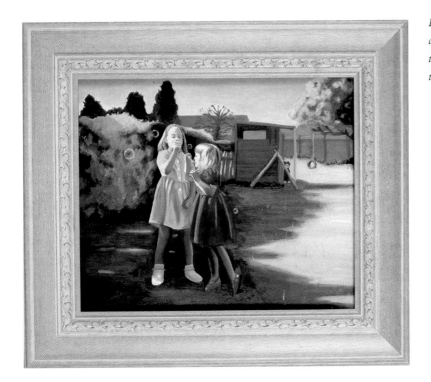

Fig 11.5 A frame can be used to echo a colour within a painting. In this example, the salmon-coloured wood echoes the flesh tones of the figures.

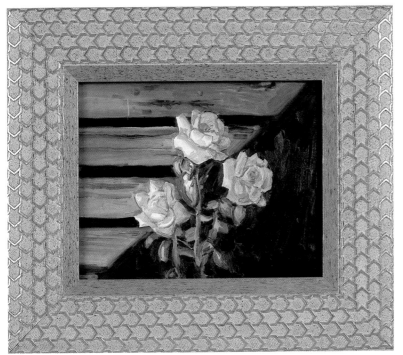

Fig 11.6 It sometimes pays to take risks and try out a more adventurous frame. In this example, the gold weave surround draws attention to this rose study.

Backing and fixing

Once you have chosen your frame, the painting will need to be fixed inside. This is a simple procedure.

Slot the painting into the frame. Fix the painting into place by tacking panel pins into the back of the frame. Tape can be placed over the pins for neatness. From the back, measure roughly one-third from the top. Mark the spot on both sides. Make a pilot hole into each mark and screw an eyelet into each hole. Thread the cord through the eyelets and pull tight. Tie neatly.

Mirror plates are another way of fixing the painting onto the wall, particularly if the painting is heavy. The plates are simply screwed onto the back of the frame via pre-drilled holes. The 'ears' are then screwed into the wall.

Fig 11.7 The materials required for backing and fixing a painting: a hammer, screwdriver, tape and panel pins. The usual method of hanging a painting is by using eyelets, for which you will need cord and a hanging hook. These are shown on the top right of the picture. Mirror plates are an alternative method of hanging a painting, particularly if it is heavy, in which case wall plugs and screws would be needed. These are shown on the bottom right.

Glazed frames

Many frames are sold with glass. You can simply dispose of the glass if it is not required (but do so with care). However, a glazed frame can add a touch of class to a highly detailed work. Oil on sketching paper would be ideal for this sort of presentation.

A window mount will be necessary, as this will provide space between the oil painting and the glass. With this protection, varnishing the painting becomes unnecessary. Mounts can be purchased ready-cut with the frame or separately. Most framers will cut a window mount for you at little extra cost.

The frame will need to be a size larger than the painting. Ensure the window of the mount will be centred on your painting. Fixing the painting onto the backing board will prevent it from slipping within the mount.

When choosing the colour of the mount, it is a good idea to bring a photograph of the painting with you. This prevents taking the original. Bear in mind that if a painting is predominantly pale, dark or strong-coloured mounts will make the painting look washed-out. One method of choosing the colour is to pick a colour that exists within the painting. Another is to take risks. The same painting presented in two different ways can look quite different.

Fig 11.8 This sky sketch was mounted on cream-coloured card and fixed into a dark frame. The cream echoes the cream within the cloud, whilst the dark frame echoes the rooftops and provides stability. A certain intimacy is achieved within the presentation.

Positioning the painting

Oil paintings will provide pleasure for years to come, so long as the following advice is followed:

i Ensure the painting is fastened securely to the wall. A large glazed painting can be heavy.

ii Avoid positioning a glossy or glazed painting opposite a window, as the reflections will make the painting hard to see.

iii Avoid areas of extreme conditions, for example, excess condensation. Hot spots, such as the chimney breast are not ideal for any painting. The alcove on either side would be better.

iv Hanging a painting beneath a spotlight or within a unit can add a welcoming look to any room.

Fig 11.9 This time, I presented the sky sketch in a deep pink mount. This is complementary to the cream within the clouds, bringing contrast. However, the pale frame reconciles this contrast by providing harmony to the surround. Within a pale frame, the painting appears more open and airy.

Chapter 12

The gallery

Oil paintings from your garden

The endless inspiration that can be reaped from the garden cannot be covered in one book. The primary aim of this book, however, is to provide a few pointers for beginners as well as for more experienced artists. The path ahead will never be so well-defined as the path in the garden and this is what makes painting in the garden exciting. One never knows where the garden will lead or what new views can be discovered within this ever-changing enclosure.

Right: St John's Wort, *25.5 × 30.5cm (10 × 12in)*

Potted Tulips, *20.5 × 25.5cm (8 × 10in)*

I began my venture with simple garden sketches. Garden sketches are always a good springboard for further inspiration. There is no plan, simply a response to the calling of the garden. Building up a collection of sketches can be the sole aim of the artist. But simple garden sketches can be used as raw material for studio paintings. Maybe simply to complete a more refined version of the sketch, to alter its tonal balance, or to make it bigger. This is what I did with *Rose Study* (see right).

Rose Study was completed in two hours. *Three Roses*, (below) was completed in two stages each of three hours. Glazes were used in the studio copy to bring out the delicacy of the petals. I altered the colour of the background and edited some of the leaves.

Rose Study will always have a raw energy that is difficult to duplicate. Its studio counterpart, *Three Roses*, however, is this raw energy tamed and directed.

Rose Study, *20.5 × 25.5cm (8 × 10in)*

Three Roses, *25.5 × 30.5cm (10 × 12in)*

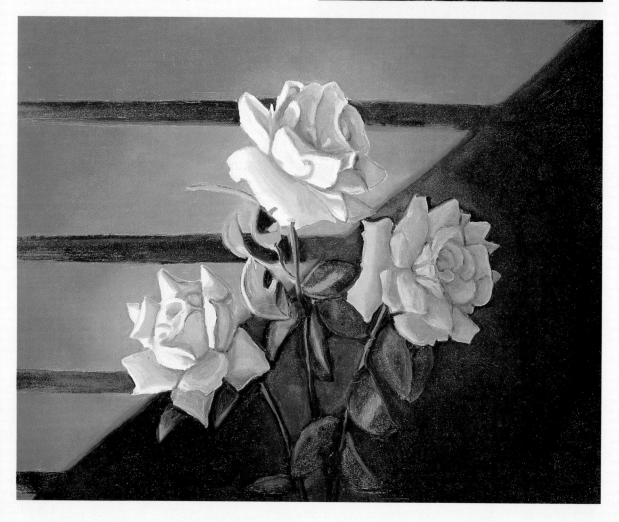

Sketches, in conjunction with photographs, can be used to create an unusual slant to the garden and its associated objects. For the two paintings on this page, *Fishpond* and *Chillies with Garlic and Beans*, I took photographs from directly above. Colour references were then made. I simplified the reflections in the fishpond, to eliminate irrelevant detail. In *Chillies with Garlic and Beans*, I kept the background simple and emphasized the shadows. In both, the result is striking.

Oil sketches can be used alone, or in conjunction with line drawings and photographs to create a different painting entirely.

Fishpond, *25.5 × 30.5cm (10 × 12in)*

Chillies with Garlic and Beans, *25.5 × 30.5cm (10 × 12in)*

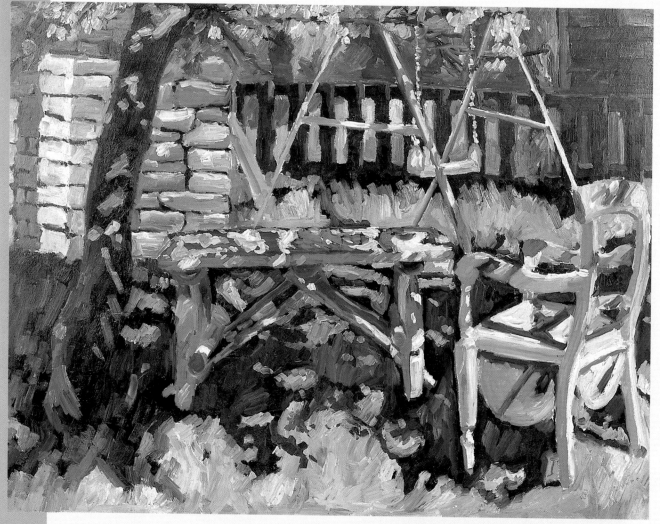

Chair and Table, 45.5 × 61cm (18 × 24in)

Chair and Table (above) was completed two years before *Sky Sketch* (see page 164). I had no plan in mind, I simply liked the setting and the dappled colours.

Throughout this period, I felt that *Chair and Table* possessed further paintings. The abstract shapes of the light and shade on the grass, for instance, could be used in a larger studio piece. However, I did not wish to use the top part of the painting, for it was too literal. I wanted to extend this abstract quality throughout the painting. This is where *Sky Sketch* came in.

I decided to combine the two sketches to knit the studio painting together. I changed the shadows slightly and used a different chair. However, it is still plain to see where the inspiration for *New Beginnings* came.

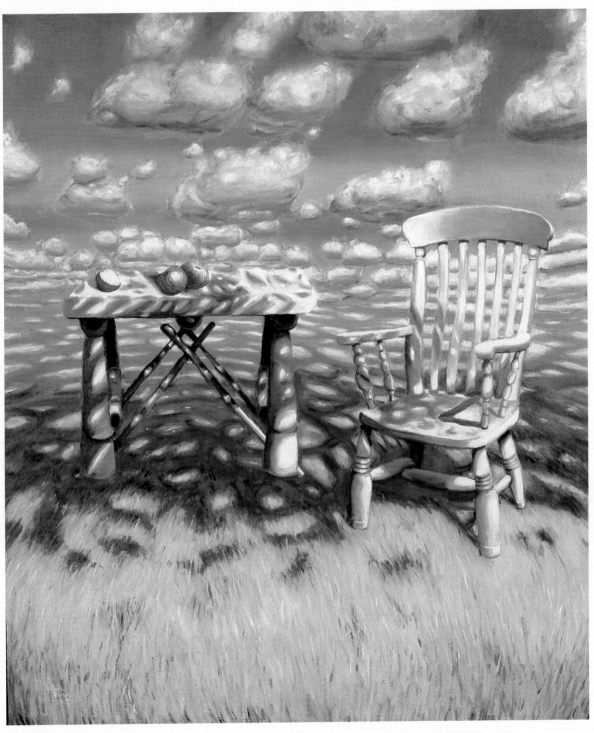

New Beginnings, *51 × 61cm (20 × 24in)*

Sky Sketch, 20.5 × 25.5cm (8 × 10in) primed watercolour paper

In similar fashion, I used other sky sketches, photographs and snow sketches to create *Undressed Salad* (on facing page). Both *New Beginnings* (on page 163) and *Undressed Salad* were completed by using glazes, similar to those shown in the demonstration of *Cooling Off* in Chapter 9.

Secret Garden (page 166) was worked from an enlarged photograph. This was done so that I could work in detail. The contrast between light and shade was heightened, particularly in the background. This emphasized the brightness of the day.

Undressed Salad, *45.5 × 56cm (18 × 22in)*

Dressing Up, *61 × 91.5cm (24 × 36in)*

Dressing Up, above, like *Cooling Off* (page 128), was completed from a series of photographs. The colours of the outfits were altered and props introduced. A little research was necessary.

Picnic, overleaf, was perhaps the most ambitious painting based within the garden. Much orchestrating was involved, as well as the implementation of numerous photographs and sketches. The light was a complex matter too. As you can see from the flesh tones, there are many reflections. The whole effect had to pull together, so that no single aspect of the painting worked against the others.

However, no matter how complex or simple the painting may be, the important thing is that it works, and it makes the viewer take a closer look. The simplest sketches can contain an elusive quality that makes every painting unique.

The garden is simple, and yet it is also complex. The garden yields much more on close inspection than first impressions will suggest. The garden also has many faces, from season to season, and even from year to year. No two days are alike.

Left: Secret Garden *45.5 × 61cm (18 × 24in)*

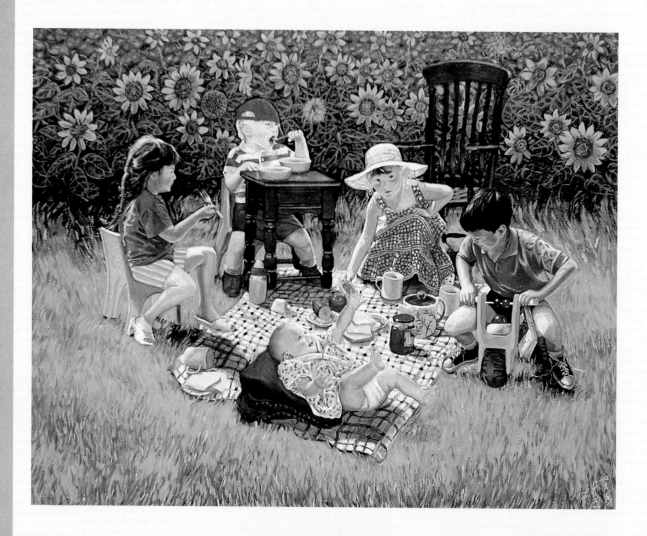

Above: Picnic, *91.5 × 107cm (36 × 42in)*

Right: Detail of Picnic

The object of this book is to encourage you to keep looking. Never think that the garden has given up all its secrets. Keep looking and you will be surprised.

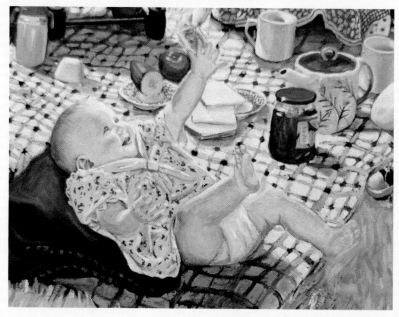

Glossary

Acrylic A water-soluble paint, made from a polymer

Acrylic primer A water-based underpaint, usually white, that seals the absorbent nature of the painting support prior to oil painting

Alkyd A synthetic resin that accelerates the drying process of oil paint

Alla prima A painting completed in one go, as opposed to layers

Bristle A stiff brush, such as hog hair or equivalent. These are ideal for robust brushstrokes and impasto

Complementary colour A colour that is situated on the opposite side of the colour wheel to a chosen colour. For example, red is the complementary colour to green

Fat over lean (Or flexible over inflexible) The process of introducing more oil medium into the oil paint when working in successive layers. This prevents cracking

Ferrule The metallic tube on the brush that connects the hair to the handle

Flags Split ends in the brush, usually bristle. This enables the brush to hold more paint

Gesso Ground pigment suspended in glue. This is applied over the painting support prior to oil painting

Glaze A translucent layer of paint, usually diluted with artists' solvent and/or oil mediums

Ground A sealant that is applied onto the painting support prior to oil painting. Different types are available, such as acrylic primer and gesso size

Harmonious colour A colour that is situated close to a chosen colour on the colour wheel. For example, blue is a harmonious colour to green

Impasto The application of thick paint

Imprimatura A tinted glaze that kills the whiteness of the ground prior to painting

Linseed oil A substance found in oil paints. When used as a medium, it adds gloss, transparency and flow

Mediums Special agents that are used to alter the characteristics of oils. For example, to thin the paint or to accelerate its drying time

Negative shape The background and foreground area surrounding the main subject matter

Oiling out The restoration of the oil content to an oil painting which has 'sunk' or become dull

Permanence The ability of a pigment to remain unchanged over a period of time

Primary colour A fundamental colour that cannot be made from the mixture of other colours

Sable A soft, springy, brush made from the fur of the sable, a small mammal. These brushes are ideal for applying detail and even glazes. Synthetic alternatives are available

Scumbling The application of thin but neat paint to produce a broken glaze

Secondary colour A colour that is produced from the mixture of two primary colours

Sgraffito The scratching of the paint surface whilst it is still wet, to reveal a different colour beneath

Sinking The loss of the oil content from an oil painting to an absorbent layer beneath. This is usually due to a poor ground or to the application of layers which have not dried properly between

Size A glue that is applied onto the painting support. Sizing is necessary before the application of an oil-based primer

Solvent A thinner for oil paint. Solvents are also used for cleaning the brushes and other art materials

Support Any surface onto which oils can be applied. Wood, card, paper and canvas are most commonly used

Tonking The system of blotting off surplus or over-worked oil paint by using newspaper or rags

Varnish A transparent, hard-drying solution that is applied onto an oil painting once it is dry. This protects the painting from damp and dirt

Wet-into-wet The application of wet paint onto a wet surface

Index

Titles of painting exercises and
demonstrations are given in italics.